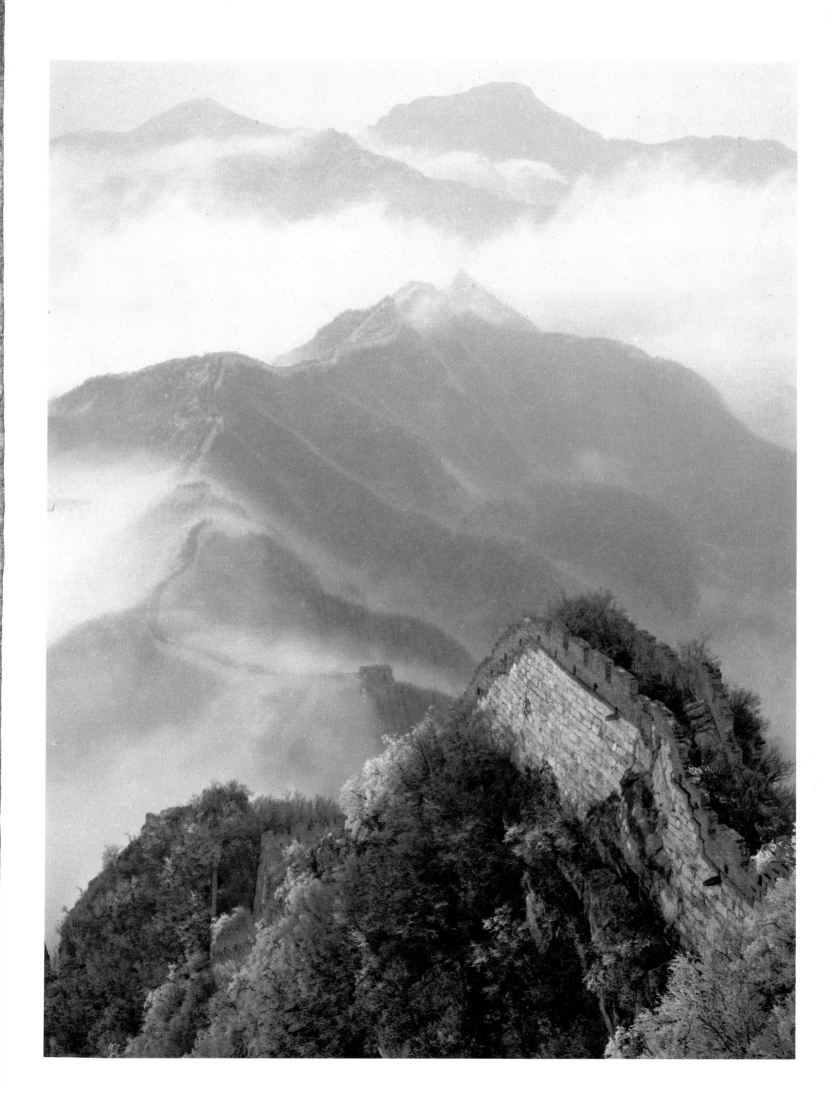

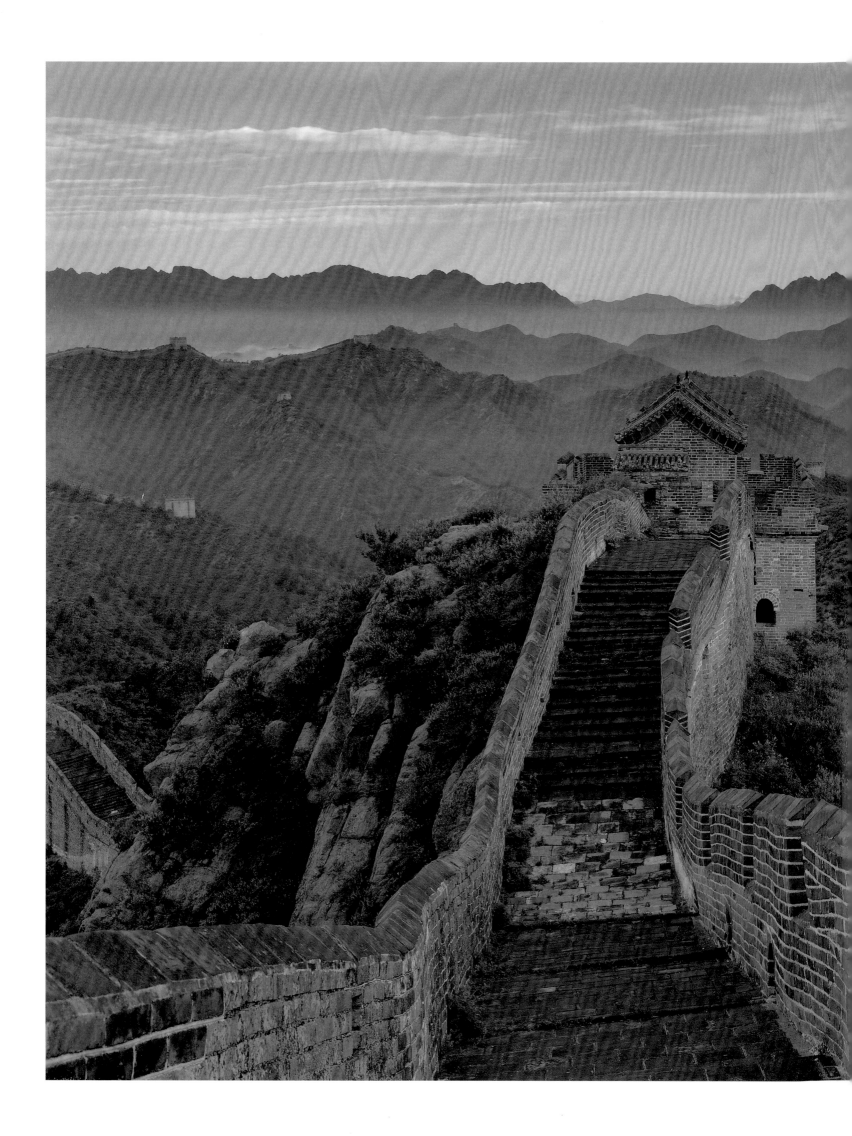

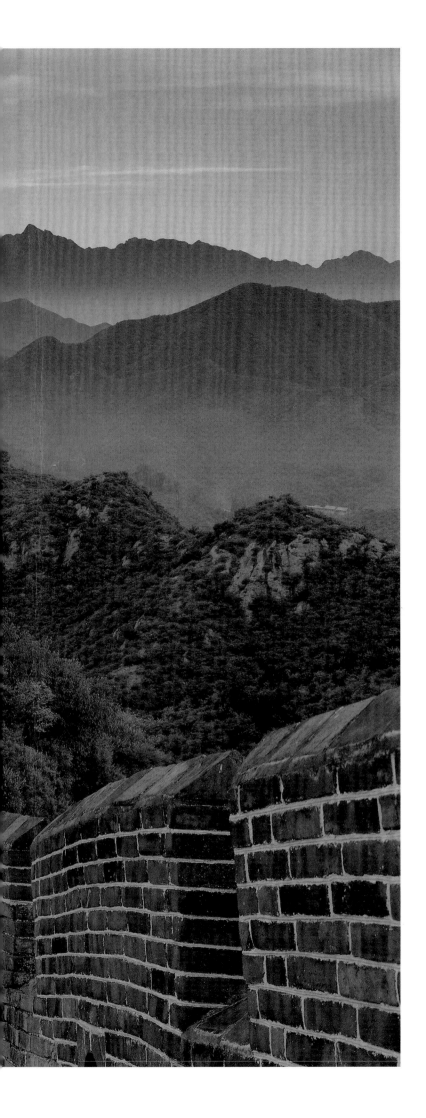

THE GREAT WALL OF CHINA

YALE UNIVERSITY PRESS, NEW HAVEN AND LONDON in association with THE MUSEUM OF FINE ARTS, HOUSTON

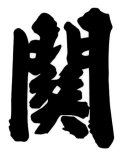

THE GREAT WALL OF CHINA

PHOTOGRAPHS BY CHEN CHANGFEN

Anne Wilkes Tucker

Foreword by Jonathan D. Spence

Cover and endsheets
JINSHANLING, HEBEI PROVINCE, 2000
inkjet photograph on silk mounted as a scroll [checklist 70]

Page i
BEIJINGJIE, JIANKOU, BEIJING, 1999
inkjet photograph on rice paper [checklist 13]

Pages ii–iii
JINSHANLING, HEBEI PROVINCE, 2000
gelatin silver photograph [checklist 60]

Published in conjunction with the exhibition *The Great Wall of China: Photographs by Chen Changfen*, organized by the Museum of Fine Arts, Houston, April 1–August 12, 2007. Generous funding was provided by The Freeman Foundation and The E. Rhodes and Leona B. Carpenter Foundation.

Right: Map of China adapted from a map in Yang Xiagui, *The Invisible Great Wall* (Beijing: Foreign Language Press, 2004).

Unless noted, photography is © 2007 Chen Changfen.
p. 22: © Sze Tsung Leong, courtesy of the artist and Yossi Milo Gallery, NYC.

p. 23: © Zhang Dali, courtesy of the artist and the CourtYard Gallery, Beijing.

p. 24: © Ma Liuming, courtesy of the artist, the JGS Foundation, and the CourtYard Gallery, Beijing.

Designed by Daphne Geismar
www.daphnegeismar.com

Set in Syntax type by Amy Storm

Printed in Singapore by CS Graphics

Library of Congress Cataloging-in-Publication Data
Chen, Changfen, 1941–
The Great Wall of China: photographs by Chen Changfen / Anne Wilkes Tucker; foreword by Jonathan D. Spence.
 p. cm.
Catalog of exhibition held Apr. 1–Aug. 12, 2007 at the Museum of Fine Arts, Houston, Texas.
Includes bibliographical references and index.
ISBN 978-0-300-12247-3 (cloth: alk. paper)
1. Great Wall of China (China) — Pictorial works — Exhibitions.
I. Tucker, Anne. II. Title.
DS793.G67C453 2007
951 — dc22 2006025332

A catalogue record for this book is available from the British Library.

The paper in this book meets the guidelines for permanence and durability of the Committee on Production Guidelines for Book Longevity of the Council on Library Resources.

10 9 8 7 6 5 4 3 2 1

XINJIANG
UYGHUR
AUTONOMOUS
REGION

1
2 3

GANSU 4

QINGHAI

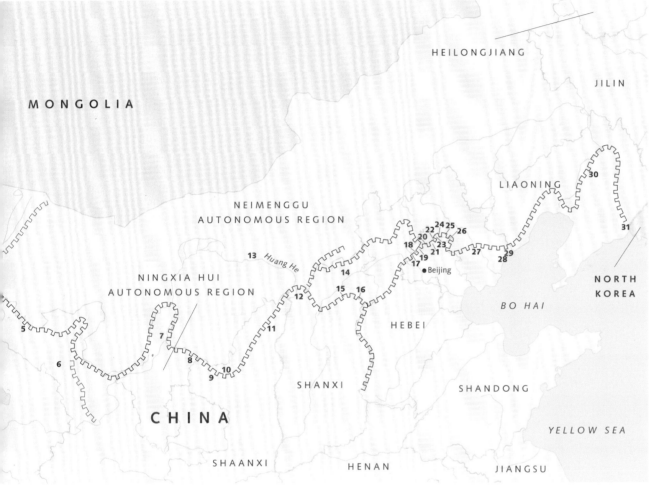

MONGOLIA

HEILONGJIANG

JILIN

NEIMENGGU
AUTONOMOUS REGION

LIAONING

30

31

13 Huang He

14

18
20 22 24 25 26
17 19 21 23 27 29
Beijing 28

NORTH
KOREA

NINGXIA HUI
AUTONOMOUS REGION

BO HAI

5

7

15 16

HEBEI

11

12

8 10
9

SHANXI

SHANDONG

YELLOW SEA

6

CHINA

SHAANXI

HENAN

JIANGSU

1	YUMENGUAN
2	YANGGUAN
3	DUNHUANG
4	JIAYUGUAN
5	SHANDAN
6	WUWEI
7	YINCHUAN
8	YANCHI
9	ANBIAN
10	JINGBIAN
11	YULIN
12	PIANGUAN
13	BAOTOU
14	DATONG
15	YANMENGUAN
16	PINGXINGGUAN
17	BADALING
18	SHUIGUAN
19	JUYONGGUAN
20	HUANGHUACHENG
21	JIANKOU
22	ZHUANGHU
23	MUTIANYU
24	GUBEIKOU
25	JINSHANLING
26	SIMATAI
27	QIANXI
28	SHANHAIGUAN
29	LAOLONGTOU
30	SHENYANG
31	DANDONG

THE GREAT WALL OF THE HAN DYNASTY

THE GREAT WALL OF THE MING DYNASTY

The Great Wall of China also comprises other unconnected wall fragments, not represented here,
some of which were built by other dynasties. This map focuses only on the walls of the Han and
Ming dynasties and may show continuous walls where only fragments were constructed or remain.

CONTENTS

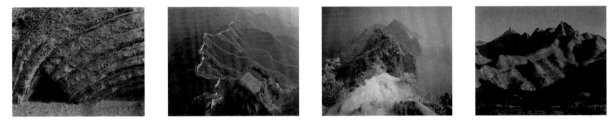

Jonathan D. Spence

Chen Changfen began to photograph the Great Wall forty years ago. Such a commitment of time and energy is not lightly made: our lives allow us only a few chances to concentrate with such tenacity on a single quest. Why did Chen choose the Wall? As Chen himself has told Anne Wilkes Tucker, "There are people who praise the Great Wall as a miracle that poor laborers built, and others who feel that the Great Wall is insignificant because it has lost its functionality. Too few people consider that the Great Wall can be a communal cultural legacy for humanity." Chen is not necessarily disclaiming the spiritual kinship he feels, through his own work on the Wall, with the hundreds of thousands of workers who struggled and died on the apparently endless project across two millennia; nor is he denying the significance of the power struggles among earlier Chinese rulers, or between such rulers and foreign border powers like the Xiongnu or the Mongols, which served as justification for the many sections of the Wall that rose and fell over time. Instead, he has chosen to define his quest as one that promotes the Wall from the realm of the particular to the universal, and to an interpretation that can yield some kind of meaning to all humanity.

Note that Chen says he is seeking a "cultural legacy." How can one find such a legacy in a wall? As Anne Tucker wrote near the end of her detailed essay on Chen's life and achievements, that is especially difficult when one is dealing with places and people that have both "powerful histories and entrenched public personas," as (for example) with architecture "that has been given national, or even international status." Tucker places the Great Wall of China in such a category, along with the Eiffel Tower, the Statue of Liberty, Big Ben, and the Sphinx. These are all cases, she believes, where the force of unending commercialized miniaturization and reproduction have stripped these structures of their clarity in a "haze of familiarity." That is quite persuasive, but I feel that there is something else that makes the Great Wall the most problematic of the five examples. Four of those in the list share key characteristics: they are unitary, fixed in time and space, datable, and designed for specific historical moments; each was successful in achieving its limited purpose. In contrast, the Wall appears to be lacking all those characteristics: it is scattered in fragmentary (and shifting) units spread across thousands of miles; it has been constantly reconfigured, rebuilt, and destroyed; its purpose

has been endlessly redefined. And, as far as we can now tell, for most of its existence the Wall was a failure.

Chen, in other words, has given himself a challenging assignment. To my mind, he has chosen a bold and ingenious route to the universalism he claims to be seeking. For he has deliberately chosen to photograph the Wall without any tightly defining reference points in time or space and—at least in the great majority of the prints chosen for this exhibition and volume— without any visible human presence or the faintest shadow of political motivation. Chen's Wall simply and wondrously exists. It is at one with the undulating folds of the mountains, at one with the clouds, the moon, the rocks, and the snow. It is a human construct without human purpose, sensually stretching its length in answer to pressures and goals that we cannot grasp, surrendering its own being into the forms from which it sprang. This, to me, is what gives a special force to Chen's intensely felt renderings.

To the historian, there is a definite strangeness in the fact that the Great Wall has, over the last century or so, become a sort of symbol or signifier for the Chinese state and the Chinese people. It was not always so. To start with, the Chinese themselves rarely spoke or wrote about the Wall. If they did, they never called it "Great"; they just called it "long." Before it was standardized as a wall it was labeled many other things: a "rampart," "frontier," "barrier," or "border garrison." The terms rarely appeared in military histories, and entire campaigns were waged without any reference to the Wall. Only in the twentieth century did the Chinese begin to argue about its purpose, its effectiveness, and its symbolic implications. The Chinese nationalist leader Sun Yat-sen espoused this new attitude, writing in his "plan for national reconstruction" in the 1920s that the Wall was "China's most famous work of land-based engineering," and "unequalled throughout all antiquity, it is a miracle." Without the Wall, wrote Sun, "the Chinese race would not have flourished as it did during the Han and Tang, and assimilated the peoples of the south" (cited in Julia Lovell's *Great Wall: China Against the World, 1000 BC–AD 2000*). Despite Sun's prestige, other contemporaries continued to find the Wall negative in its impact over time: it ate up cash and human lives, it was unimaginative conceptually and ineffective strategically, and it led China to be seen as static and tradition-bound.

And in any case most of the scenic sections reachable by tourists near Beijing had been constructed no later than the mid-1500s.

There was, therefore, nothing foreordained about the Communist leadership of China gradually adopting the Wall as a positive symbol of national achievement and celebrating its dramatic twists and turns in vast tapestries and paintings, an omnipresent backdrop to all formal occasions. Mao Zedong began this process as he came gradually to accept the (initially mocking) parallels between himself and the ruthless founding emperor of the Qin, who had first had the idea of linking various shorter stretches of wall in northwest China into a more coordinated defensive system. And it was Mao's successor Deng Xiaoping who authorized the funds to repair long sections of the Wall, both to raise money from tourism and to salute, according to Lovell, "the Chinese people's extraordinary intelligence and untiring spirit."

Among Western visitors to China the Wall also took time to become "Great." One of the first to examine the structure closely was the Scotsman John Bell, who traveled to China in 1720 as the physician for a Russian embassy to the court in Peking. After months spent traversing Russia and Siberia from Moscow to Irkutsk, the party finally swung south and passed through the Wall into China at the town of Kalgan. Bell took time out to climb onto the Wall, which at various moments in his memoirs he called "celebrated," "famous," "long," "strong," and "endless"—though never "Great." The Wall, as Bell wrote in his *Journey from St. Petersburg to Pekin, 1719–1722*, seemed redundant, since China's western and northern borders were so well protected by "impregnable bulwarks" of mountains and deserts. But his final view was favorable, and in some ways it anticipated the later effusions of Sun Yat-sen; as Bell wrote, "I am of the opinion, that no nation in the world was able for [sic] such an undertaking, except the Chinese. For, though some other kingdom might have furnished a sufficient number of workmen, for such an enterprise, none but the ingenious, sober, and parsimonious Chinese could have preserved order amidst such multitudes, or patiently submitted to the hardships attending such a labour. This surprising piece of work, if not the greatest, may justly be reckoned among the wonders of the world." By the mid-eighteenth century this concept of the Wall as "wonder" was widely held in Britain. We can see this from Dr. Johnson's cheerful observation

to Boswell that a visit to the "celebrated wall of China" would be proof of any traveler's "spirit and curiosity," and enough in itself to confer honor and prestige upon one's children.

Chen Changfen has chosen to be the universal chronicler of the Wall even as he senses that he is losing what he grew to cherish because of the immutable logic of the "communal" culture he has sought so long to foster. Mass tourism on an unprecedented scale and poorly conceived reconstructions have both been taking their toll. As he said to Anne Tucker at another moment in their interview, "After all, the Great Wall is a wall, and it is a wall that divides. If the Wall no longer exists, then people can get along with each other without obstruction....I have no power to protect the original state of that place." It is true that Chen cannot control the rhythmic rattle of the ski lifts that now waft the tourists to previously inaccessible sections of the Wall, but through his strongest images he has made a new kind of viewing possible, and he has left us an unforgettable sense of the Wall's oneness with the land. As John Bell wrote of his 1720 excursion to the Wall, the mere sight of the Wall in the far distance was enough to raise everyone's flagging spirits after the fierce realities of the tundra and the desert: "About noon we could perceive the famous wall, running along the tops of the mountains, towards the north-east. One of our people cried out 'Land,' as if we had been all this while at sea." At his strongest, through his images of the Wall, Chen can play in a similar transformational way with our sense of time, space, and substance.

ACKNOWLEDGMENTS

In February 2004, Judit Stowe, a former member of the photography support group at the Museum of Fine Arts, Houston, asked to show me the work of a Chinese photographer from Beijing. In 2001, Judit and her husband, Ian Stowe, had moved from Houston (via New Delhi) to Beijing. Looking to meet other photographers, Judit attended an opening at a nonprofit gallery run by the photographer Chen Changfen. She left her card, then she met Chen a few days later, initiating a deep friendship between the two photographers. Chen showed Stowe's photographs in his gallery, and she "decided to promote his art." She brought Chen's photographs of the Great Wall to the Museum of Fine Arts, Houston, confident that I would also admire them. She was correct. I met Chen that fall and talked to him about his work. We also visited the Jiankou section of the Great Wall, where I perceived for the first time the quiet beauty of light on the aged stones and recognized with wonder the awesome task of building the Wall and what it must have cost in human lives as well as in other national resources. I also realized the transformative nature of Chen's photographs. Throughout the project that resulted in this exhibition and book, Ian and Judit Stowe have been generous with their time, hospitality, and energetic support.

Chen Changfen and I are also grateful that Director Peter C. Marzio and the Trustees of the Museum of Fine Arts, Houston, endorsed our proposal for an exhibition and book and have supported the research required. Other members of the museum staff who have participated in the planning and execution of the show and book include Toshi Koseki, conservation; Marisa Sánchez and Annalisa Palmieri, exhibition and catalogue preparation; Bill Cochran, exhibition design; and Diane Lovejoy and Heather Brand, catalogue planning and editing. Christine Starkman, associate curator, Asian art, has generously guided my research in Chinese art and religions.

Four translators have been invaluable: Tina Tan, a conservator at this museum; Da Li, director of Deya Tech, Beijing; Christy Chang of the Chinese Community Center, Houston; and Edwin Van Bibber-Orr of Yale University, who translated the interview. Chen Peng, Mr. Chen's able son, also served as a translator, as well as the driver for our trips, as camera and printing assistant to Mr. Chen, and in numerous other important capacities. We are also grateful to

two other members of his family, Zhu Yu "Judy," his daughter-in-law, who also helped translate conversations, and Pei Shuping, his wife.

For me to understand Mr. Chen's photographs and the Great Wall as it exists in China today, we made two additional trips along the Great Wall: one from Beijing east to Laolongtou, and another, much longer, tour from Dunhuang back to Beijing in a four-wheel-drive vehicle. On these two excursions we were met with exceptional hospitality and support from many people, including Wang Jin, a photographer and the director of Jiayuguan Great Wall Museum, Gansu Province; Liu Jirao, Airport Group Corporation, Gansu Province; Han Jianjun, photographer and photography director at *Datong Daily*, Shanxi Province; Liu Yong Jiang, president, Tangshan City Tourism Administration, Hebei Province; Liu Fanshou, director, Qianxi Prefecture Cultural Sport Bureau, Hebei Province; Wang Shuzhen, vice chairwoman, Qianxi County of CPPCC, chairwoman, Women's Federation of Qianxi County, and director, Qianxi Women's Legal Service Centre; Sun Baoli, Xizhazi Village, Huairou District, Beijing; and Zhou Wanping, photographer, Jinshanling, Hebei Province.

My experience of the Wall was enhanced by visits to the Jiayuguan Great Wall Museum and to the Ming fort at Qingshanguan, Tangshan City. The Jiayuguan museum's extensive exhibition labels were particularly helpful to me in trying to grasp the complicated history of the Wall; and the Qingshanguan fort, which has been converted into a comfortable inn and conference center while preserving the integrity of the structure and its past, revealed how the fort might have appeared and functioned four hundred years ago, when its ingenious gate also served as a dam and sluice in times of flooding.

Mr. Chen took great care that I should understand China's history and culture beyond the Great Wall, and for their assistance in my education I would like to thank Zheng Xinmiao, director of Palace Museum, and Li Wenru, deputy director of Palace Museum and director of the Forbidden City Publishing House, Beijing; Sun Jinqiang, photographer, Shaanxi Northwest University, Xian, Shaanxi Province; and Zhang Hai Yan, photographer, Yungang Buddhist Caves, Shanxi Province. For securing the reproductions and granting the reproduction rights for essay illustrations in the catalogue, I would like to thank Sze Tsung Leong and the Yossi Milo

Gallery, New York; Ma Liuming, Zhang Dali, and Jeremy Wingfield, director of the CourtYard Gallery, Beijing, and the Joy of Giving Foundation, New York.

Finally, I would like to thank Haun Saussy, professor, Department of Comparative Literature, Yale University, for his wise counsel; Shawn Eichman, curator of East Asian art, Virginia Museum of Fine Arts, for his assistance with the mural at Hongshixia; Jonathan D. Spence, Sterling Professor of History, Yale University; Daphne Geismar, designer; Melissa Jolin, map designer; and the following staff at Yale University Press: Patricia Fidler, publisher, art and architecture; Kristin Swan, editorial and production assistant; Mary Mayer, production manager; and Heidi Downey, manuscript editor.

Anne Wilkes Tucker
The Gus and Lyndall Wortham Curator of Photography
at the Museum of Fine Arts, Houston

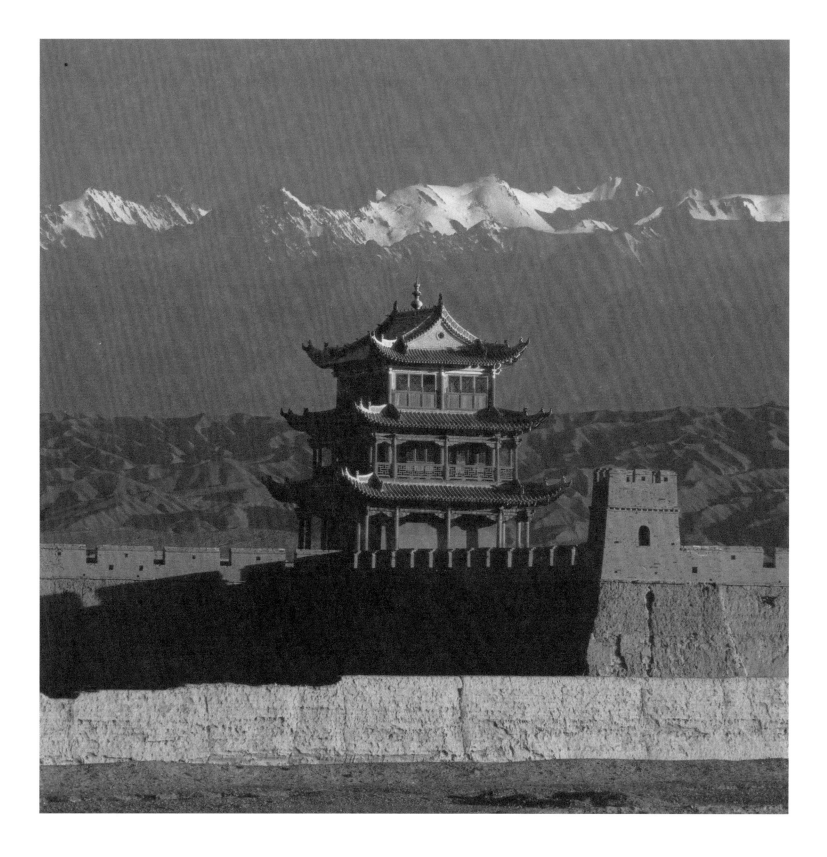

Plate 1 JIAYUGUAN, GANSU PROVINCE, 1986, inkjet photograph on rice paper [checklist 4]

THE WAY OF THE WALL Anne Wilkes Tucker

Chen Changfen (born 1941) has photographed the Great Wall of China since 1965, most intensely since the mid-eighties, finding this legendary structure to be an endless source of inspiration. His photographs embody forty years of thinking about the Wall, its history, and its path across China's diverse terrains. Major themes within this distinctive series include the different types of construction employed by various dynasties, the Wall's continually evolving states of decay and reconstruction, its situation within natural environments and in different seasons, and, finally, the Wall as a representation of extraordinary human vision and labor. What distinguish his pictures from thousands of others' views of the Wall are his unique perceptions. His work is simultaneously straightforward and detailed and deeply influenced by Chinese paintings and philosophy, most particularly Daoism.

The Great Wall of China is a legendary, discontinuous network of wall segments built by various dynasties to protect China's northern boundary. The combined length of these segments has not been established; records are inconsistent, and what remains has not been surveyed. Ancient Chinese texts have cited the Wall's length as 10,000 li (about 5,000 kilometers, or 3,125 miles). Modern estimates range from 2,400 kilometers/1,500 miles to 6,400 kilometers/ 4,000 miles.[1] The earliest extensive walls were built by Qin Shi Huang (260–210 B.C.) of the Qin dynasty (221–207 B.C.), who first unified China and is most famous for the standing terracotta army left to guard his tomb. The other major Wall-building dynasties were the Han (206 B.C.–A.D. 220), Sui (A.D. 581–618), Jin (A.D. 1115–1234), and most famously Ming (A.D. 1368–1644). Contrary to popular assumption, the walls of each dynasty did not necessarily follow preceding footprints, and they were not all of the same construction. What survive today are predominately the stone and brick walls built by the Ming dynasty. However, in western China there are two-thousand-year-old fragments of the Wall from the Han dynasty that were built with materials more appropriate to the desert environment: mud with layers of willow branches or tamped mud (plates 2, 15, and 17). The oldest surviving stone walls are in Neimenggu (Inner Mongolia), built during the Qin dynasty (plates 3 and 59). Existing Wall segments extend from the Yumen gate in far western Gansu Province, through the arid lands surrounding and inside the horseshoe loop of the Huang He (Yellow River), and through the

1
Arthur Waldron, *The Great Wall of China: From History to Myth* (Cambridge: Cambridge University Press, 1990), 5–6; Li Jin, "In Memory of Greatness," *Beijing Weekend*, October 22–24, 2004, 4.

Plate 2 DUNHUANG, YUMENGUAN, GANSU PROVINCE, 1998, gelatin silver photograph [checklist 30]

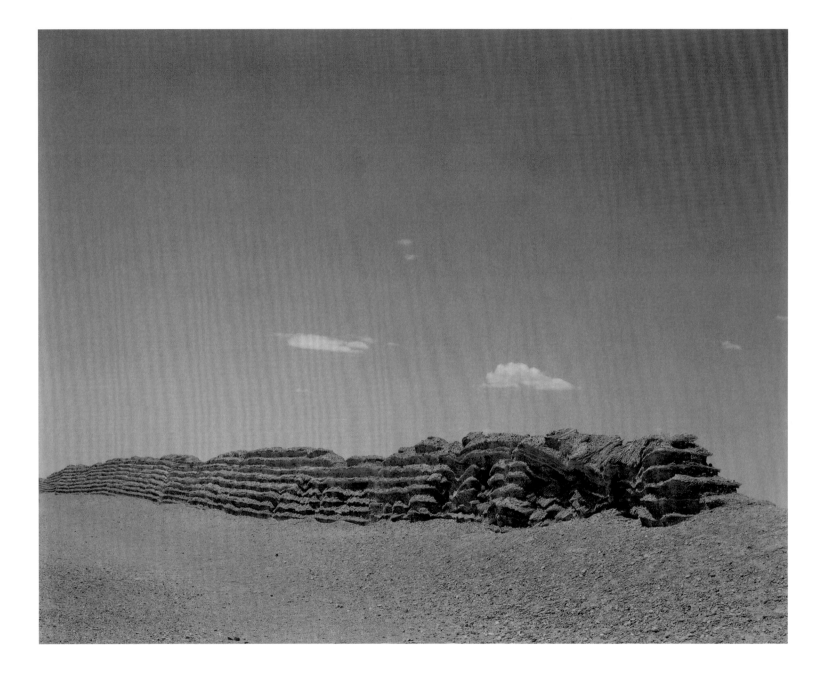

Plate 3 BAOTOU, NEIMENGGU PROVINCE, 1999, gelatin silver photograph [checklist 28]

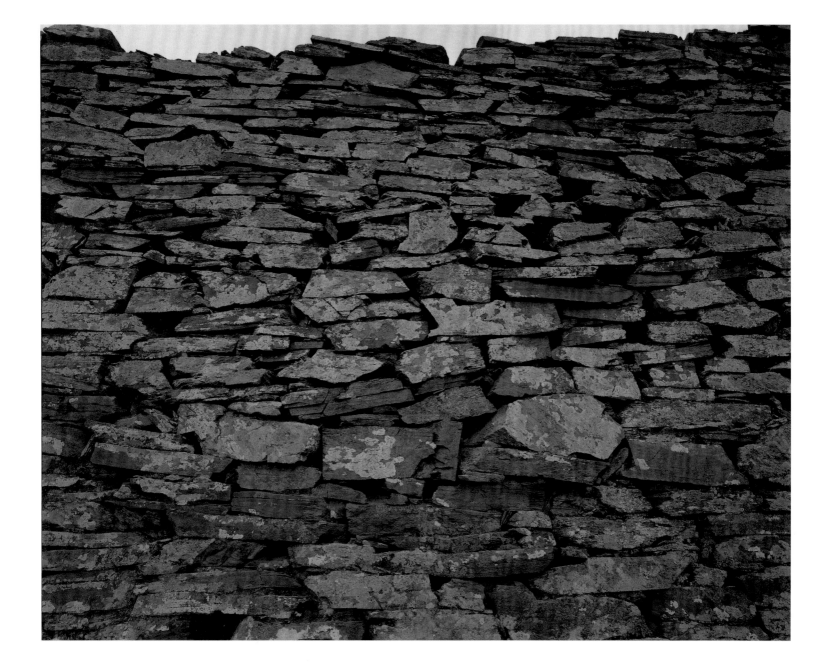

2

For Voltaire's changing views about the Wall, see Waldron, *Great Wall of China*, 207. Kafka's vision of being a worker on the Wall is radically different from that in China as exemplified by the legend of Meng Jiangnu, discussed later in the essay. Consider this passage: "Every fellow-countryman was a brother for whom one was building a wall of protection, and who would return lifelong thanks for it with all he had and did. Unity! Unity! Shoulder to shoulder, a ring of brothers, a current of blood no longer confined within the narrow circulation of our body, but sweetly rolling and yet ever returning throughout the endless leagues of China." Franz Kafka, *The Great Wall of China: Stories and Reflections*, tr. Willa and Edwin Muir (London: Secker & Warburg, 1933; New York: Schocken, 1946), 154. Kafka goes on to speculate that what united China was not the emperor's decision to build the Wall, but the humanity that it took to do the job.

3

Heinrich Schliemann, *Le Chine et le Japon au temps présent* (Paris: Librairie Central, 1867). This book was translated into Chinese and was an important text for Chen Changfen.

4

Waldron, *Great Wall of China*, 203. See Waldron for extensive discussion of the "cult of the wall" beginning with foreign visitors in the late nineteenth century. Also see Gao Minglu, *The Wall: Reshaping Contemporary Chinese Art* (Buffalo, N.Y.: Albright-Knox Art Gallery and University of Buffalo Art Galleries; Beijing: Millennium Art Museum, 2005). See especially chapter 6 for a discussion of the Wall as a national symbol after Japan invaded Manchuria in 1931, as well as for the shifts in attitudes in contemporary Chinese art.

mountains west, southwest, north, and east of Beijing to the Bo Hai, the smallest of a series of seas leading to the Pacific Ocean (plate 40; see also map, pp. vi–vii).

The Great Wall has not enjoyed continuous reverence, or even relevance, in China. The concept of the Great Wall as a two-thousand-year-old, unbroken stone barrier was initially an invention of Europeans. Beginning in the sixteenth century, Westerners re-created the Wall—according to their own imaginations—in books, diaries, illustrations, and even maps. Intellectuals who never actually saw the Wall, ranging from the philosopher Voltaire (1694–1778) to the novelist Franz Kafka (1883–1924), lauded it as a great feat of human engineering and as a tribute to the human spirit, and compared it to the Pyramids (Voltaire) or the Tower of Babel (Kafka).[2] Other Westerners, such as Heinrich Schliemann (1822–1890), did make pilgrimages to the Great Wall and wrote about their travels.[3] Historian Arthur Waldron established that the popular concept of the Great Wall and even the name Great Wall appear "to have entered modern Chinese consciousness not directly from any indigenous tradition, but rather via a detour, which took it first to Europe."[4]

After the fall of the Ming dynasty in 1644, the Wall was no longer used for military defense; it was not maintained, and it was not considered part of China's national identity. Scholars have pointed out that prior to the twentieth century the image of the Wall rarely appeared in Chinese art. It was not until the 1930s, when the Wall was the site of important battles in the Sino-Japanese War and appeared widely in the press as well as in propaganda and popular art, that it became a rallying symbol of national pride. During the rule of Mao Zedong (1949–76), the Great Wall represented little beyond the imperial dynasties' oppression of conscripted laborers. In the 1950s there was enough interest to restore the Badaling segment near Beijing, but during the Cultural Revolution (1966–76) the Wall was in severe disfavor. People were even encouraged to take bricks from the Wall to use in their farms and homes (plate 4). President Richard Nixon's visit in 1972 signaled China's willingness to open for trade. This led to the arrival of increasingly large numbers of businesspeople and, eventually, tourists for the first time since the founding of the People's Republic. With a rising number of tourists, other sections of the Wall were slowly restored.

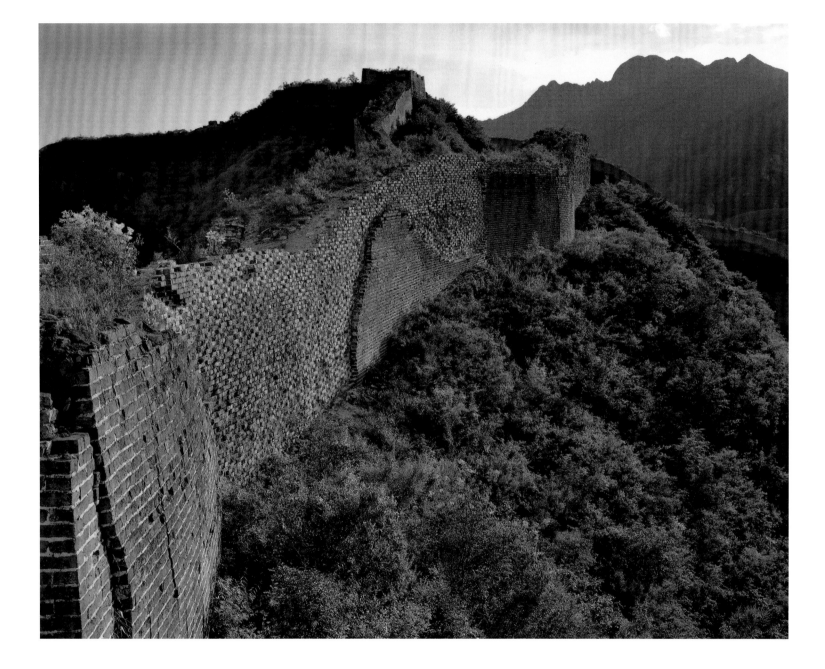

5
Chinese Premier Deng Xiaoping (1904–1997) declared, "Let us love our country and restore our Great Wall." Cited in Waldron, *Great Wall of China*, 1.

6
The pinyin spelling, Daoism, is being used here, although many scholars continue to use the Wade-Giles spelling, Taoism.

After Mao Zedong's death, the Chinese government recognized the Wall as a unifying symbol for the nation.[5]

Chen Changfen began to photograph the Wall twenty years before the Chinese government officially adopted it as the symbol of China in 1984. While this exhibition presents a small fraction of Chen's work, it conveys a fertile range of themes and ideas that Chen has investigated, each informed by traditional Chinese art, history, and philosophies, particularly Daoism and Confucianism.[6] His work also presents a blend of traditional and contemporary technical processes. Although the show concentrates on the work he has made since 1996, when he acquired an 8 x 10 inch camera and began to favor black-and-white photographs, it also includes two sections of color work. The first group comprises images printed from 2¼ inch square negatives and printed with an inkjet printer onto large sheets of specially made rice paper. More recently, Chen has made panoramic photographs, which he prints on silk using an inkjet printer and mounts in the style of traditional Chinese scrolls.

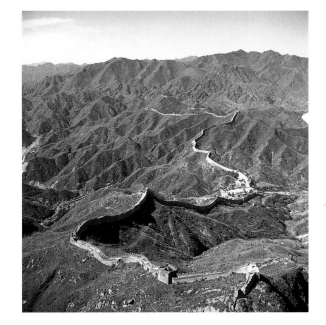

Each of these three bodies of work denotes distinct evolutions in his thinking and style.

Chen first photographed the Wall in 1965 when he made an aerial photograph of Badaling section of the Wall. He was on assignment for the Civil Aviation Administration of China (CAAC), where he had worked since graduation from CAAC's school in 1963 (fig. 1). Since then he has continued to photograph the Wall on his own on weekends and vacations, most seriously since the late 1970s. He is the first to admit that his earliest images, none of which are now included in his portfolio, existed on relatively simple planes of understanding. His project

Fig. 1

AERIAL VIEW OF BADALING, BEIJING, 1965
Chromogenic photograph

on the Great Wall began in earnest as Chen emerged from the Cultural Revolution needing a restorative project. He decided that the Wall was a creation of beauty, a potential source of national pride, a physical challenge, and the basis of endless aesthetic, philosophical, and historical ponderings for an intelligent, talented, and driven man.

Chen is knowledgeable about the Great Wall's complicated history and well aware that this history is laden with myths, misinformation, and conflicting views on its significance and meaning, but he avoids the scholarly disputes that now cloud a clear chronology and understanding of the Wall. He picks and chooses among the facts and myths, guided by those that best stimulate his imagination and those relevant to the sections of the Wall to which he has been repeatedly drawn. He understands that myths linger in the popular imagination because they have contemporary relevance. For instance, there is the legend of Meng Jiangnu, who, on discovering that her husband had died as a conscripted laborer on the Wall, cried until a segment of the Wall collapsed, revealing his bones, which she could then properly bury. The Meng Jiangnu Temple in Shanhaiguan honors this devoted wife, whose story epitomizes the hardships of the conscripted workers and their families, as well as the Wall builders' capacity for human cruelty. Recently folklorists have discovered similar stories that originate with wars and therefore undermine this legend as particular to the Great Wall. But whether or not Lady Meng existed, her story has survived and flourished because it highlights real hardships. Perhaps hundreds of thousands of people died during the Wall's construction. The first builder, Emperor Qin, was so associated with tyranny that he and his walls became emblems of cruelty and of a morally corrupt government. The delicate frozen weeds at the base of the Wall in the photograph *Beijingjie, Jiankou, Beijing*, 1997 (plate 5), are Chen's homage to these conscripted laborers. It is important to him that his photographs pay tribute to both the sacrificed lives and the great vision and skills of the builders.

As Chen researched, explored, and continued to photograph the Great Wall through the 1980s, his pictures evolved in distinct stages. His photographs in the 1960s and 1970s were made using 35mm and 2¼ inch film, and he used both color negative and slide film. In the early years, obtaining film was difficult, and Chen had to order it by mail.[7] In 1979, after he switched

7
Chen talks about how wars and strife disrupted the development of photography in China. From 1925, China was in a civil war between the forces of Chiang Kaishek and Mao Zedong. This conflict was interrupted by the war with Japan between 1937 and 1945. Civil war resumed until Mao's victory in 1949. The Cultural Revolution raged between 1966 and 1976. Given these conflicts and the closed-border policy of the People's Republic, Chinese photographers could not be aware of aesthetic evolutions in the rest of the world. For an extensive and insightful document of the evolution of Chinese contemporary photography since 1976, see Wu Hung and Christopher Phillips, *Between Past and Future: New Photography and Video from China* (Chicago: Smart Museum of Art, University of Chicago; New York: International Center of Photography; and Göttingen, Germany: Steidl, 2004). Prior to 1976, most photographers were photojournalists or worked in other capacities in a documentary style. For a selection of work by photographers of Chen's generation, see *China: Fifty Years Inside the People's Republic* (New York: Aperture, 1999).

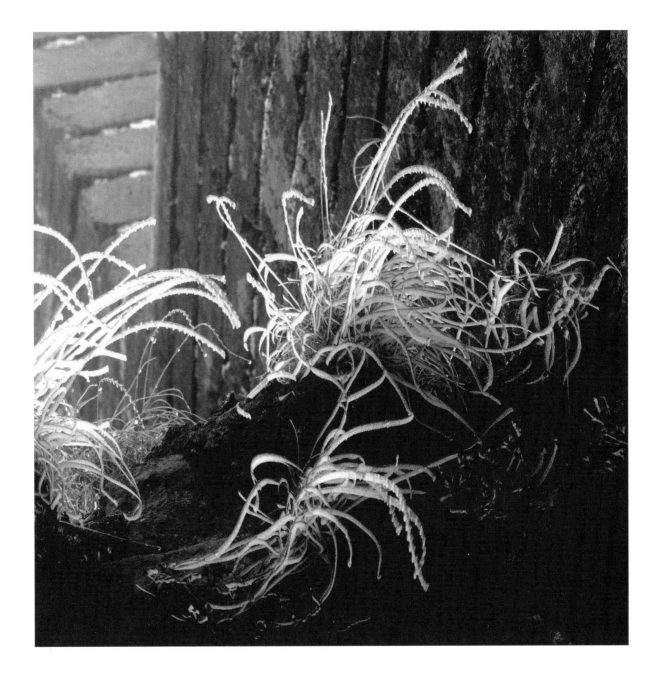

to using 2¼ inch negative film exclusively and a Hasselblad camera owned by the CAAC, his images became more sophisticated.[8] His decision to work only with a larger-format negative was a result, not a cause, of a new approach to the Wall. He said recently that he switched primarily because the 35mm images could not satisfy his artistic or spiritual needs, but there was also technical dissatisfaction.[9] The new camera gave him more control in exposing the negative, and the larger negatives yielded more control over printing quality. At this stage he also decided that photographs that operated as simple documents could no longer express his thoughts and feelings about the Wall. He began to make straightforward photographs that also exist on metaphoric levels, such as the weeds signifying the workers. However, he does not use the word *metaphor*. Instead, he expresses himself through concepts based in Eastern philosophies.

Although Chen has photographed the Great Wall at many locations, he assumes no obligation to complete a checklist of the major gates and fortresses or to weight his portfolio equally with work from each province. However, he has photographed at the forts or gates built at the four most famous passes along the Wall: Shanhaiguan in the east, Juyongguan near Beijing, and Jiayuguan and Yangguan in the far west. Each of these sites is strategically located. For instance, Jiayuguan (plate 1) is where the Qilian Mountains and the Hei Mountains in the Mazong mountain range narrow to form the Hexi Corridor, known as China's throat because it was where the Silk Road entered the country.[10] The Chinese character photographed in *Shanhaiguan, Hebei Province*, 2005 (plate 6), is the word *guan*. "The pass in Chinese is called *guan*," Chen wrote, "and means passageway. The word *guan* in this picture is one of the characters in 'Tian Xia Di Yi Guan' [The first pass under heaven], written on a huge plaque at Shanhaiguan in 1472. It is the key passageway connecting place [to] place.... The passes are the most important components and symbols representing the Wall. In addition, the character of *guan* is the combination of the words *passageway* and *silk*. Thus, the character *guan* possesses both a pictorial meaning and is a significant form of beauty."[11]

Chen lives in Beijing, and the segments of the Wall within a day's drive are those that are best represented. Chen has most frequently photographed at Jiankou, a ten-kilometer

8
In 1965 Chen began photographing with a Rolleiflex camera, then used the department's Hasselblad camera until he purchased his own Hasselblad in 1990.

9
Chen Changfen in conversation with the author, October 2005.

10
"*Silk* was coined from the Greek name for China (Seres). Silk became so closely identified with China and foreigners craved it so much that the nineteenth-century writer Ferdinand von Richthofen labeled the overland routes radiating from China to Central Asia, West Asia and Europe as the Silk Roads." Morris Rossabi, "The Silk Trade in China and Central Asia," in James C. Y. Watt and Anne E. Wardwell, *When Silk Was Gold: Central Asian and Chinese Textiles* (New York: Metropolitan Museum of Art and Harry N. Abrams, 1998), 7.

11
Chen Changfen, e-mail message to the author, March 15, 2006.

stretch of the Wall built in the late fourteenth century by the Ming dynasty.[12] It has an elevation between eight hundred and one thousand meters and is ninety kilometers northeast of Beijing (fig. 2). His intimate knowledge of that section has yielded a rich array of interpretive visions within a limited geographical space; thirty-one of the images in this book were taken here. These images range from the views looking up to the towers impossibly perched on high ridges to photographs made at eye level or above, but with different lenses, and in different seasons and climates, and with both color and black-and-white film. The images are so varied that one could not recognize them as repeated views of the same location without the identifying titles. The variety evokes significantly different responses. The views looking up and those aimed sharply down both emphasize the sheer drops on each side of the Wall. Chen employs the vertiginous elevations to provoke wonder that the Wall was ever built. Who stood on this peak and chose the next peak and the ones undulating into the far distance? How often were they wrong, and at what cost to those following their command? Who carried up the workers' and soldiers' food and water, and how often? What was it like for soldiers to be stationed here, so isolated and vulnerable to extreme temperatures and climates? And what was it like for Chen to photograph in such conditions?

At Jiankou, Chen has been drawn to a particular crenellated tower that sits precariously above a dramatic vertical split of stone (plates 7 and 8). Sometimes he pulls back to emphasize the bending ribbon of wall on each side of the tower with no apparent access to any of it. By shifting to a vertical format and a different lens, he emphasizes the massive geological

12
Locations within Jiankou include Jiangjunshouguan, Suobolou, Tianti, Xidaquing, Yinfeidaoyang, Youlouling, Zhenbeilou, and parts of Beijingjie.

13
Chen Changfen, fax to the author, April 10, 2006.

Fig. 2

JIANKOU, BEIJING, 1998
Inkjet photograph on silk mounted as scroll

thrust upward that created this split in the rock. He also pays homage to the tradition in Chinese painting in which deeply cut crevasses reveal that mountains exist in states of flux and change, a Daoist idea expanded below. Also, exposed bare rock reveals the "essence" of stone, another important concept of Daoism and other Eastern philosophies. In the vertical photograph, the tower that caps the rising stone appears to have evolved from the stone itself. There are also five photographs of the peak called Yingfeidaoyang, which is translated as "The eagle flies facing upward." This peak is so high, said Chen, "that even the eagle must crane its neck climbing sideways to reach it."[13] Chen has utilized both the dizzying view down from Yingfeidaoyang and the steep ascent up to it. In one image, the wall rises at what appears to be an angle sharper than 90 degrees (plate 21), before plunging to the valley below. Rising and falling or thrusting out and coming back are important themes in traditional Chinese painting. It is simultaneously and simply what the Wall does—climb and descend—and another opportunity for Chen to refer to symbolic meanings embodied in the tradition of Chinese art.

By choosing his viewpoint, Chen makes the Great Wall look whole or reduced to rubble (plates 56 and 57). Sometimes the Wall dominates the picture; at other times one must scan for its traces (plates 27 and 67). When using color film, Chen relishes the orange glow from late-afternoon light that sets the stones and bricks afire (plate 32). "I am even more touched," Chen said, "when the morning sun rises and the east wind blows, symbolizing the onset of prosperity and luck. In Chinese this is referred to as *zi qi dong lai*. The vicissitudes

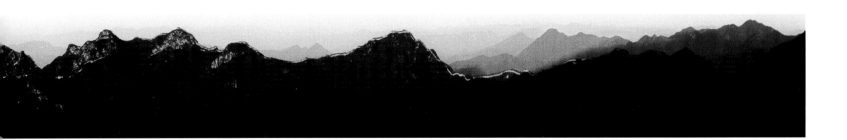

Plate 7 JIANGJUNSHOUGUAN, JIANKOU, BEIJING, 2002, gelatin silver photograph [checklist 47]

Plate 8 JIANGJUNSHOUGUAN, JIANKOU, BEIJING, 2002, gelatin silver photograph [checklist 48]

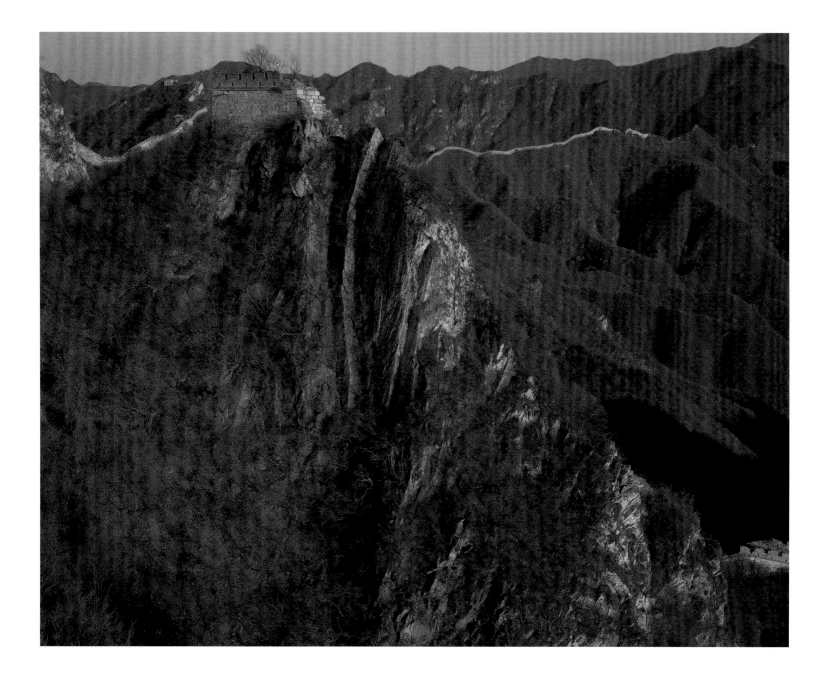

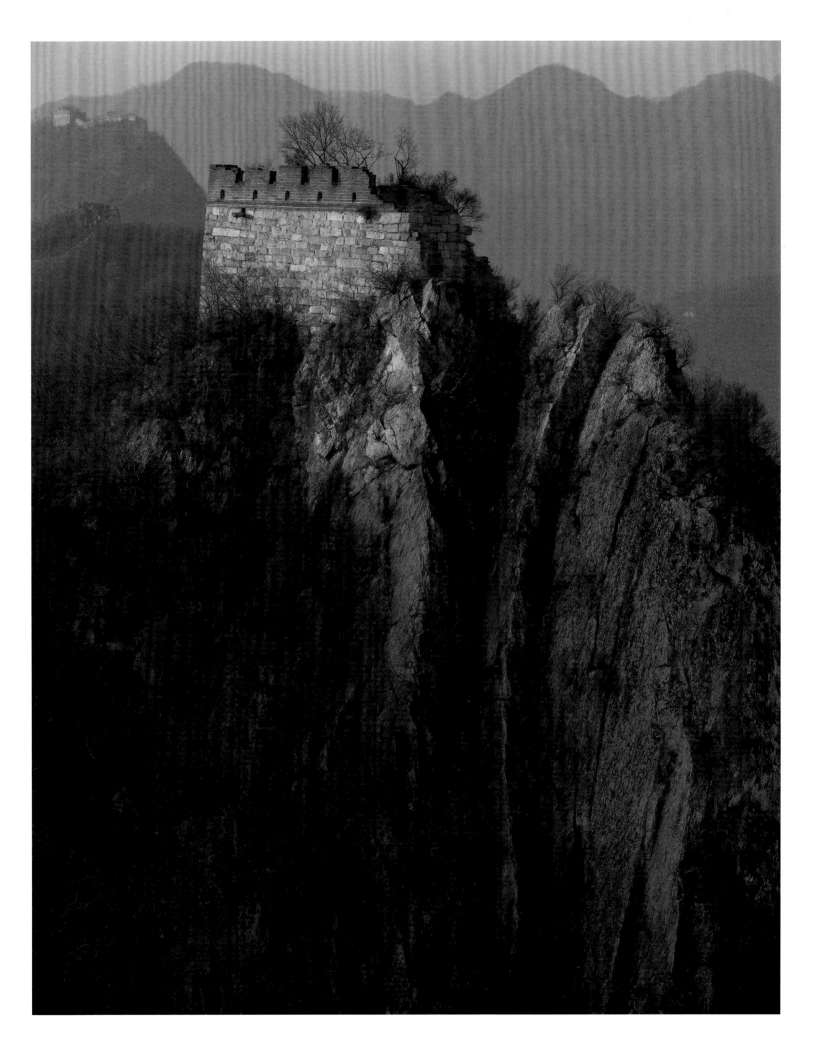

of the Wall and its glory over the years pulse with vitality."[14] In other images he draws more attention to the trees that now grow mid-wall and densely along its sides (plate 10). He uses light to emphasize the Wall or shadows to obscure it, depending on the components or relationships that he wishes to reveal. The more one reads about the Wall and experiences it personally, the more one understands the depth of perceptions embedded in each picture and how much knowledge can be perceived through his vision.

If Chen's only goal was to accurately document the Great Wall, the image at Laolongtou, the eastern end of the Wall (plate 40), might include the modern restorations and tourist attractions that negate any atmosphere of antiquity. Instead, he waited for the Bo Hai to freeze so that he could walk out on the ice and capture the fort's shape, concealing the unmarred textures of new stones, as well as the tourist shops, the signs suggesting where to photograph, and the recently built Ming-style tower at the top of the steps.[15] Chen usually leaves documentation of modern travesties to the Wall to others. By excluding the people, highways, factories, modern buildings, and farms that encroach on and daily destroy sections of the Wall, Chen is eliminating from his pictures major aspects of the Wall's modern reality. This is Chen's most critical decision, and the one from which other decisions follow.

Excluding people from the vast landscapes departs from traditional Chinese pictorial traditions, which favor including a solitary figure in monumental landscapes. Chen's omission of modern life and people ensures that the scenes in his pictures seem timeless, a technique employed by many photographers who wish to prevent clothing and other details from dating their images. With the exception of a few pictures that include a distant city or a jet trail (plates 21, 45, and 65), he re-creates views that were possibly visible to the men who built the Wall and to those who lived in its fortresses over the centuries, with the important exception that their Wall was intact and still functional. But most important, the decision to diminish the presence of modernity focuses his pictures on the Wall itself, as well as on its relation to the landscape, the seasons, and the time of day.

This strategy also dictates that Chen work in remote regions or at times when other people are unlikely to be visible. Only those who live along the Wall, intrepid hikers, and other

14
Ibid.

15
His perspective also responds to that section's name, which translates as Old Dragon's Head. There used to be a dragon's-head statue at this site, but in his photograph the shape of the Wall entering the sea evokes a slithering dragon's head.

16
There is a fellowship among the photographers who specialize in photographing the Wall. Among those that I met are Sun Jinqiang (from Xian), Wang Jin (director of the Jiayuguan Museum), Han Jianjun (from Datong), and Zhou Wanping (at Shinshanling). Each has published at least one book of photographs, usually focusing on a specific section of the Wall.

contemporary Chinese photographers are as committed as Chen to roaming remote sections of the Wall.[16] When Chen does photograph people in his pictures, they are those who live along the Wall in the most rural regions, such as the ninety-two-year-old woman with bound feet who lives near Datong, the shepherds who have climbed on the Wall to watch their flocks, and a man and his oxen (figs. 3 and 4; see also p. 101, fig. 10).

Fig. 4

ZHENCHUANPU, DATONG, SHANXI PROVINCE, 2001
Gelatin silver photograph

Fig. 3

YINCHUAN, NINGXIA PROVINCE, 1990
Chromogenic photograph

Chen's photographs of isolated regions convey impressions that are radically different from those of most visitors. The Great Wall is a pilgrimage site for the Chinese, as well as for foreign tourists. Most foreign visitors go to Badaling, the closest restored section near Beijing, about seventy kilometers from the city. Consequently, particularly in the summer months, their experience of the Wall may be simultaneously shared with hundreds, even thousands, of other tourists. The sightseers push past shops, stalls, and canned music, barely able to see the Wall on which they stand. The crowded conditions give them little opportunity to notice the meaningful details that could inform their understanding. For instance, at this and every rebuilt segment, the original stones have different textures and colors than the replacements have; they also reflect the light differently. If one takes the time to notice, the older ones are more beautiful.[17] Perhaps a tour guide will point out that the top of the Wall has crenellations only on the north side, which protected the soldiers as they aimed down on attacking armies. (Although it is difficult to imagine any army choosing to attack by climbing these mountains.) Visitors who make the steep ascent to one of the towers will notice how the Wall clings sinuously to successive ridges in convolutions so complex that it is difficult to imagine how it was built. Even when the Wall is so crowded that all other aspects are obscured, this is the lasting impression and the primary source of wonder carried away by visitors. This is the vision that a photographer must both confirm and refresh with new approaches.

When Westerners seek to describe this view of the Wall, they usually say that it "snakes" across the mountains, but the Chinese say that the Wall is a dragon, a multilayered reference. The dragon is the symbol of the emperor and his imperial command, which built the Wall, and like the Wall, the dragon symbolizes power.[18] In addition, wrote the art historian Cliff G. McMahon, the dragon signifies "the sign of Tao itself, the general spirit force uniting and animating all of reality."[19] McMahon cites the master Gu Kaizhi, who noted that in a mountain painting, "there should be shapes that writhe and coil like dragons."[20] When Chen shows the Wall's writhing passage across the mountains he is bringing to mind both a sinuous dragon and the coiling shapes of rivers, valleys, and mountain paths in Chinese paintings. As Chen

17
In the late afternoon the old stones glow and reflect the light, making the replacement stones appear dull. We decided that the new stones had not "earned" the glory emitted by the older ones.

18
"The first appearance of the dragon in Chinese literature is in the *Yi jing*. From Han Dynasty (206 B.C.–A.D. 220) on, the dragon came to represent the emperor, the son of Heaven. It is a male symbol, and therefore yang." Carol Michaelson, *Gilded Dragons* (London: British Museum Press, 1999), 91–92.

19
Cliff G. McMahon, "The Sign System in Chinese Landscape Paintings," *Journal of Aesthetic Education* 37, no. 1 (Spring 2003): 73.

20
Ibid., 74, quoting from Arthur Waley, *An Introduction to the Study of Chinese Painting* (New York: Charles Scribner's Sons, 1926), 49. Waley uses Wade-Giles spelling for the master Gu Kaizhi, spelling it Ku K'ai-chih.

21

On a trip in 2004, tomb guards informed us that members of their families had held their jobs for four hundred years, but that all of their children now live in cities. After these guards retire, their jobs will go outside the family.

22

Chen Changfen in conversation with the author, September 2004. The Confucian scholar Xunzi (Hsün-tzu, c. 310 B.C.) stated that "in order to avoid any possibility of mistake, the heart should be kept peaceful and empty." Information received April 8, 2006, from http://www.taopage.org/emptiness_1.html.

points out in his interview in this volume, his photographs work on various levels, one of which is his understanding of the dragon in Chinese art and in Chinese symbols.

Chen often previsualizes what he will photograph and in what season. For instance, he knew that the light in *Zhuanghu, Beijing*, 1996 (plate 9), falls on that tower only on one or two days of the year and that there are only a few days when light will rake across the Buddhas carved on a gate in *Juyongguan, Beijing*, 1986 (plate 31). He is often in a predetermined place when the sun rises, which means that he may have to camp on the Wall or depart for the desired vantage point at 2 or 3 o'clock in the morning. On occasion, he has walked for days along the Wall to get to a strategic vantage point.

Chen is an amiable man who converses as easily with high-ranking government officials as he does with a village goatherd. From those who live along the Wall, many of whose families have lived there for centuries, he gathers family stories, as well as valuable information about seasonal weather patterns and local vegetation.[21] Knowing when the pear trees in a particular section will bloom (plate 24) and that the trees in the valley will burst into autumn colors one month after those on the higher peaks turn red (plate 29) helps him plan trips and position himself on the Wall for the desired photograph. He has also employed various farmers to carry equipment and supplies on particularly arduous treks. To achieve the perspective from the base of the Wall in the photograph *Xidaqiang, Jiankou, Beijing*, 2001 (plate 23), he had to push his way through trees and shrubs so dense that he was unable to bring his camera with him. Instead, his photographic equipment had to be lowered down to him on ropes from the top of the Wall. While the villagers may enjoy his company and share information about their regions, that does not mean they understand his obsession. Some tease him that he must have lost something valuable there to return so often.

Chen's images are informed by years of walking the Wall in all seasons and conditions of light and weather. At age sixty-six he scrambles upright and surefooted along the often danger-ously deteriorated Wall. He has returned to some sections of the Wall more than a hundred times, not always to photograph. Being on the Wall, he says, is a way to "keep a placid mood," which is essential for his work.[22] This solitary approach yields different images from

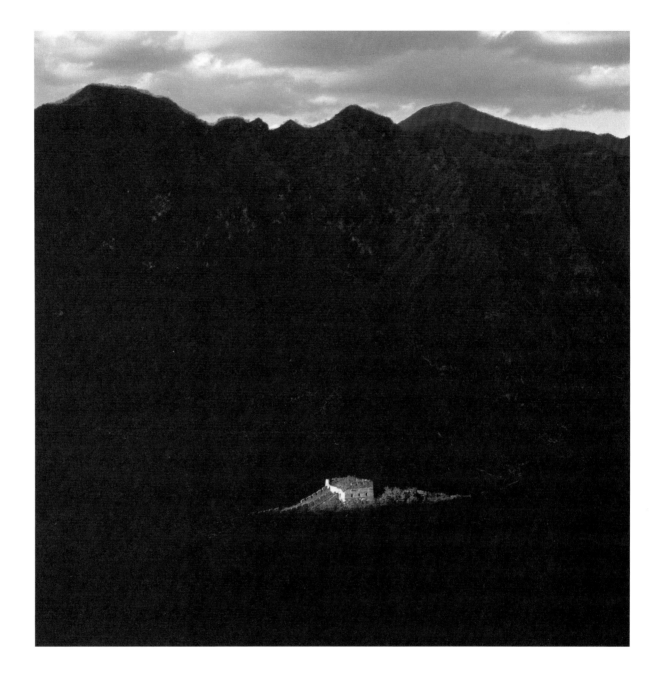

23
Margaret Y. K. Woo, "Boundaries Without Walls: Chinese Laws and the Public/Private Divide," paper presented at "The Walls" conference, State University of New York, Buffalo, October 22, 2005. Quoted with permission.

those one would make while walking the streets of densely populated, rapidly changing cities. Given the recent social and economic changes in China, his respect for the Wall and his contemplative photographs are out of sync with art by other internationally embraced contemporary Chinese artists, whose works are more experimental, idiosyncratic, and purposefully subversive of the status quo. Younger artists have been more inclined to question the Great Wall as a worthy symbol of modern China. In contemporary Chinese art since the 1980s, the meaning of the Wall has evolved relative to artists' choices to embrace or reject prior perceptions. Chen's pictures, imbued with meanings based on traditional Chinese philosophies, religions, and aesthetics, are in sharp contrast to artworks by those who see the Wall as a manifestation of the country's past conservatism, which blocked China from the outside world, and as a symbol of that conservatism today. (For instance, the Chinese government's Golden Shield project, designed to censor Internet content, is often referred to as the Great Firewall of China by those outside the country.) Chen's sources of inspiration and creativity are different from those of younger artists, and one can put his work in context by considering the production of those artists, particularly as related to walls.

Surrounding walls are historically critical to Chinese architecture and gardens. Besides those around homes, which enclose central courtyards, the oldest walls are those around cities, few of which survive today. As Professor Margaret Y. K. Woo wrote in a recent paper, "Walls are a tangible reminder of the separation of the inside from the outside, the private from the public, the family from the nation state, the empire from foreign invasion. From courtyard walls to city walls to the Great Wall of China, Chinese walls protect the old and the familiar from the new and the foreign."[23] One of the most dramatic forms of change in modern China is that, particularly in the large cities, traditional building styles are being abandoned. Since 2002, Harvard-educated, Mexican-born Sze Tsung Leong (born 1970) has photographed this rapid transition from walled homes to the International style of glass and steel in urban China (fig. 5). In the foreground of *Xinjiekou, Xuanwu District, Nanjing*, 2004, one sees the destruction of two-story buildings from the imperial period, all with red tile roofs and some with the traditional interior courtyards. Beyond these homes and shops are the six-story buildings of earlier

urban renewal, which are also being demolished, and then, the ring of skyscrapers. Unlike Chen's photographs, Sze's prints are large (40 x 48 inches), as has become the norm in contemporary art, but like Chen's images they are also achieved through wide-angle lenses that capture both a wide view as well as one of great depth and detail. Sze's vision, like that in Chen's late work, is seemingly impersonal, offering a carefully observed, sharply detailed, and

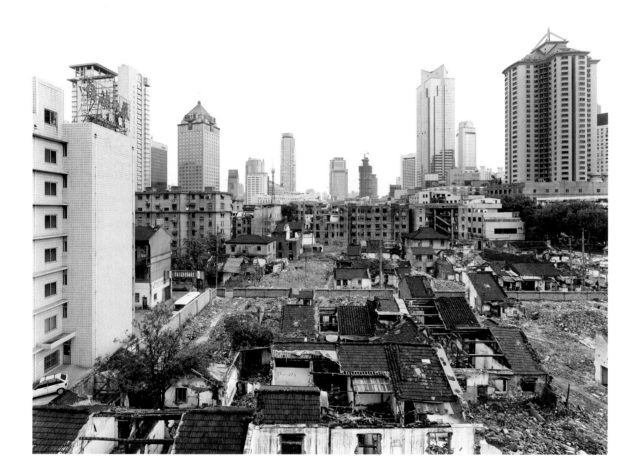

Fig. 5

Sze Tsung Leong
XINJIEKOU, XUANWU DISTRICT, NANJING, 2004
Chromogenic photograph, courtesy of the artist
and Yossi Milo Gallery, NYC

24
Hung and Phillips, *Between Past and Future*, 217.

25
See Gao Minglu, *The Wall*, chapter 5, and Hung and Phillips, *Between Past and Future*, 26, 109.

aesthetically engaging insight into China's rapid transitions. Even when showing neighborhoods that extend for blocks, Sze's pictures are mostly devoid of people, but unlike Chen, Sze is willing to digitally remove people, trees, and other distracting elements from his pictures to achieve the eerie sense of emptiness that characterizes his work.

The Beijing artist Zhang Dali (born 1963) addressed the same phenomena of rapid change with a more personal style in a series titled *Dialogue with Demolition*, 1995–2003 (fig. 6). At street level, he painted an iconic profile of his own invention on a soon-to-be dismantled wall. Then he broke though the walls within an outline of this profile to reveal the encroaching new city or to feature historical sites that were about to be overshadowed by the new buildings. The profile emphasizes the human element of the rapid transition and personalizes the cost in human terms. By incising his graffiti on the semidemolished walls, Zhang claims them as his own artwork. He then preserves this work in photographs. In stating his approach to photography he wrote, "My camera is not only my eye, but also a tool for my thinking."[24] Similarly, when the "Beijing East Village" artist Ma Liuming (born 1969) walked naked on the Great Wall in 1998, it was an expression of personal freedom and was primarily about his own conflicts regarding his effeminate face and male body. The Great Wall served as a dramatic backdrop and as an emblem of the conservatism he sought to subvert (fig. 7). [25]

Fig. 6

Zhang Dali
DEMOLITION: FORBIDDEN CITY, BEIJING, 1998
Chromogenic photograph, courtesy of the artist, the
CourtYard Gallery, Beijing, and the Museum of Fine Arts, Houston

Other performance artists who emerged in the 1980s and 1990s, many of whom also staged their performances on the Wall, offered yet more diverse approaches.[26] Like Chen, some of them focused on the tragic tales of the Wall's workers, combining that remembered pain with the more recent horrors of the Cultural Revolution. But unlike Chen, they did not simultaneously celebrate the Great Wall as a magnificent accomplishment or as a positive symbol of traditional values. Their performances presume that lost lives and traditions are to be mourned, but that the past is irrelevant in the modern and global age. Other artists employed elements of modern civilization, such as U.S. currency, daily newspapers, replacement

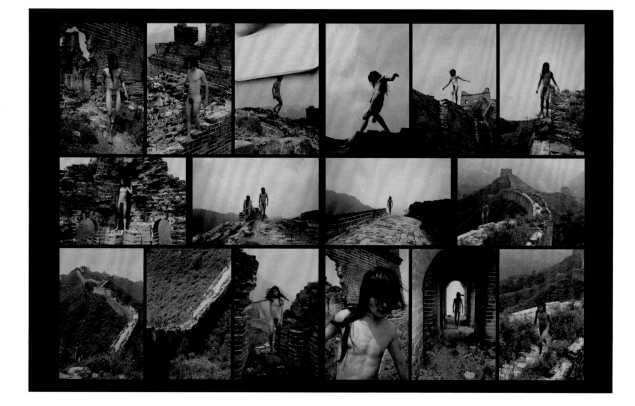

Fig. 7

Ma Liuming
FEN-MA LIUMING WALKS ON THE GREAT WALL, 1998
Chromogenic photograph, courtesy of the artist, the JGS
Foundation, and the CourtYard Gallery, Beijing

26
See Gao Minglu, *The Wall*, chapter 6, and Hung and Phillips, *Between Past and Future*, 22–30.

27
Gao Minglu, *The Wall*, 201.

28
This is a basic assumption of modern nuclear physics.

bricks made of titanium, and Coca-Cola bottles, in their performances on the Wall. These signs of modernity that Chen excludes or keeps at a great distance in his work are critical to the work of artists for whom China's capacity to rebuild the Wall is another sign of modernity. Other performance artists are also using the Wall to criticize certain aspects of that modernity or to confront through the comparison of ancient and modern the challenges faced in transforming China from a rural to a modern industrial nation. They are using the Wall's emblematic status and building their expressions on that status rather than addressing the present-day nature of the Wall itself.

Chen shares with other contemporary artists a respect for what has been referred to as the soul of the Wall. In different ways, explained independent curator Gao Minglu, some Wall-based projects "treated the Wall as analogous to a living being."[27] For these artists, Minglu continued, "restoration of the Wall was only possible through psychological or spiritual means, rather than physical restoration via brick and mortar." These works or performances had a shamanistic element. In 1988 the group called Concept 21 held what was in essence a funeral for the Wall, allowing the birth of a new national identity. In 1993, expatriate Cai Guoqiang created a ten-thousand-meter-long "wall" of lit gunpowder, forming "a 'dragon of fire' that was supposed to awaken the Wall" from centuries of sleep and neglect. Gao Minglu does not specify what type of soul or spirit these artists envisioned or whether any of them cited specific religions or traditions.

Chen's sense of the soul of the Wall is manifest in his deep respect for it as something that has its own history, integrity, and even breath. His concept of the Wall is grounded and deeply informed by principles from Daoism. One of the precepts of this philosophy turned religion is that all things are made up of *qi* (vital energy or breath, pronounced "chee"), which is in constant movement and flux. Daoists believe that physical matter cannot be distinguished from its basic substance, qi, and thus, that matter and energy are interchangeable.[28] At times one senses a vibrancy in Chen's pictures, an undulating transmission of energy, of light, or of something intangible that might have been inspired, and transmitted to the picture, by this belief (see pp. i–iii and plate 39).

Daoism is one of the three teachings of ancient China, the other two being Confucianism, a largely secular philosophy, and Buddhism, a religion that originated in India and was introduced to China in the first century A.D. Both Confucianism and Daoism are indigenous to China. The idea of the Dao (also called Tao, and translated as "the Way") was first articulated in the sixth century B.C., but the earliest formulations absorbed beliefs from the Bronze Age (fifth to third centuries B.C.), including the belief in yin and yang and the symbolism of the Eight Trigrams to be discussed later. Confucius also lived in the sixth century B.C., and his philosophy and Daoism evolved from their inherently different positions over the following centuries. Various Buddhist ideas were absorbed by both Daoism and Confucianism, yet each of the three teachings retained its distinct character.

In the book *Taoism and the Arts of China*, Stephen Little gives a concise summary of this complex religion, which has, like the Wall itself, been reinvented in the West—at least certain aspects of it, such as feng shui—to fit the Western imagination. Little wrote:

> Tao means a road, and is often translated as "the Way." Tao is conceived as the void out of which all reality emerges, so vast that it cannot be described in words. Beyond time and space, it has been described as "the structure of being that underlies the universe." Significantly, Taoism has no supreme being. Instead there is the Tao itself, underlying and permeating reality....In the Taoist version of cosmogenesis, there was first the Tao, empty and still. Then gradually, primal energy (*yuan qi*) was spontaneously generated out of the Tao. For many cosmic eons this numinous energy swirled in a state of chaos known as *hundun*. The Tao then generated the complementary forces known as *yin* and *yang*. The creative interaction of these forces directed the primal energy into patterns of movement and transformation, which in turn generated the machinations of the universe. This process is symbolically expressed in the *Daode Jing*

29
Stephen Little, *Taoism and the Arts of China*, with Shawn Eichman (Chicago: The Art Institute of Chicago in association with the University of California Press, 2000), 13–14. The quoted passage is from Michael Loewe, *Chinese Ideas of Life and Death* (London: George Allen and Unwin, 1982), 27–28. *The Daode jing* is the classic text, which achieved its final form in the fourth or third century B.C.

(Tao-te-ching: Classic of the Way [Tao] and its power), traditionally attributed to the sage Laozi....Inherent in this understanding of the Tao and its workings is a vision of universal order that gave structure to people's daily lives in traditional China. All natural phenomena were understood in terms of *yin* and *yang*.[29]

Since at least the Song dynasty (960–1279) and perhaps earlier, the *taiji* diagram (fig. 8) has symbolized yin and yang within the Dao. The black (yin) and white (yang) shapes within the circle (the whole of life) represent the eternal coexistence and interrelationship of opposites—two energies that cannot exist without each other, and that wax and wane in a continuous cyclical transformation of one force into the other. In order to be content, human beings must accept that the only constant in the universe is change and that all things and transformations are unified in the Dao. According to the ancient assignments, things associated with yin include fluidity, softness, passivity, coldness, emptiness, and darkness. So, for example, the moon, water, earth, and women are all considered yin. Among the traits of yang are hardness, assertiveness, heat, force, and light. So the sun, stones, heaven, and men are yang. All natural phenomena and patterns are understood in terms of yin and yang. For instance, noon is full yang, sunset is yang turning to yin; midnight is full yin and sunrise is yin turning to yang. This flow can also be expressed in seasonal changes and directions. South and summer are full yang; west and autumn are yang turning to yin; north and winter are full yin; and east and spring are yin turning over to yang.

The concepts of yin and yang are essential

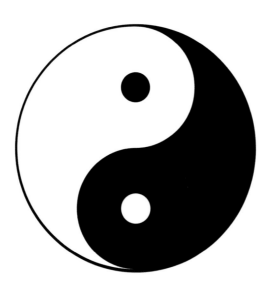

Fig. 8

Taiji diagram

to any understanding of Chen's work. When looking at his photographs, one becomes conscious of the ever-changing connection between nature and the Wall and of the shift in dominance. Sometimes the Wall cuts a bold path across a mountain, desert, or field. In his panoramic photographs made in Ningxia Province (plates 52 and 53), the Wall is a high, bold barrier across vast flat stretches of agricultural and pasture lands. In both instances, man, not nature, has broken through the ancient defense. (The cuts are too clean to have been nature's wearing-away.) But the cuts allow a return to a natural order in which flocks of sheep as well as vehicles can traverse the Wall. In other photographs, trees grow in the center of the Wall (plates 10 and 50), or winds and expanding ice have broken and toppled the stones (plate 35). Conversely, some of Chen's photographs, in which the Wall is worn and broken, document segments that have since been restored with new bricks and mortar and by the removal of the trees (plate 65).

Is Chen Changfen an architectural photographer or a landscape artist? The very nature of the Great Wall's long, thin presence on the land makes this separation impossible and the division antithetical to the concept of yin and yang. Only when photographing a relatively small section of the Wall could Chen have excluded the natural environment, but that has never been his intention or his practice. His close-up views of the Wall usually include branches or the shadows of trees (plates 18 and 30). The Wall is physically and philosophically inseparable from the great variety of its natural settings and from the cycle of the seasons and the cycle of each day. [30] While walking, he offered commentary to me on foreseeable moments in natural cycles: "Autumn is coming. There will be mushrooms here. These vines are the first to turn red. This forest is primarily maple trees, and it will be all red leaves by the advent of autumn in mid-September. The snakes will be gone then, but in the summer we share the Wall. They like to sun themselves."[31] (The observation that he and the snake should share the Wall is consistent with the Daoist belief of living in balance with the natural world. Later I learned that Chen's zodiac sign is the snake, so there are layers of meaning in his remark.) The rich varieties of terrain, seasons, light, climate, and elevations that Chen presents are intrinsic cycles. Everything in life is constantly changing and coiled in harmony.

30
See discussion in interview regarding the incompleteness of the Wall without nature, p. 116.

31
Chen Changfen in conversation with the author, September 2004.

Plate 10 BEIJINGJIE, JIANKOU, BEIJING, 1997, gelatin silver photograph [checklist 43]

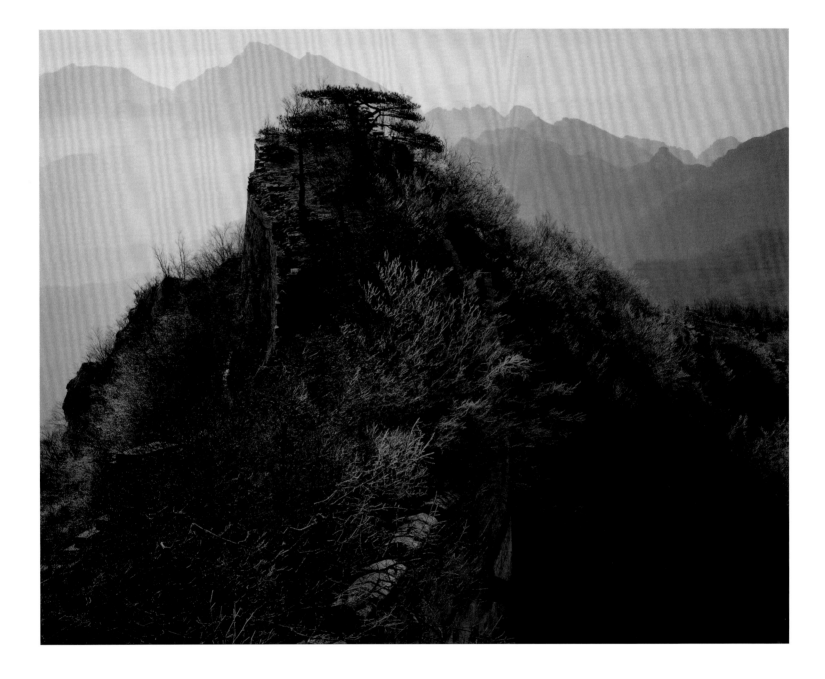

The belief in yin and yang is embedded in each of Chen's pictures, but he has overtly cited it in three images. In *Niujijiaobian, Beijing*, 1989 (plate 11), he selectively framed the curving Wall, its shadow, and the snow-covered ground to evoke the taiji diagram. In 1983 he envisioned a picture, *Ri Yue* [Sun Moon] *Yantai, Shandong Province*, that he executed two years later by making a double exposure of a particularly red sunset (yang) and a cool blue-green crescent moon (yin) (fig. 9). The idea for this picture was based on the Chinese character 易 (meaning change), which includes the symbol of the sun on the top and the moon on the bottom. This character, now written as 易, is the first character for the *Yi jing* (Book of changes), or the *I Ching*, as it has become known in the West.[32]

In another photograph, *Yulin, Shaanxi Province*, 2005 (plate 12), Chen took great pains to record a ceiling fresco in a small, dim cave that was carved into Hongshixia (Red Rock Gorge) under the Ming dynasty fort near Yulin.[33] The caves are much older than the fort, ranging from the Tang dynasty (618–906) through the Xixia period (c. 982–1227), with some later modifications during the Yuan (1260–1368) and Qing (1644–1911) dynasties. The mural could date from the twelfth or thirteenth centuries, or perhaps it was part of restorations to the caves in the Jiaqing period (1796–1820). According to Shawn Eichman, Asian art curator at the Virginia Museum of Fine Arts, "The center [of the mural] shows the arrangement of the *Yin-jing* [Yi jing] trigrams, known as the King Wen arrangement, or the *houtian* 'posterior heaven' arrangement, encircling a taiji diagram. This is a variant on the typical yin-yang circle. The *houtian* arrangement of the trigrams is meant to reveal the movements of yin and yang energy as they are manifested in the world.…Regarding the two dragons chasing pearls around the outside border, one of them is white and the other is red, but the original color has probably oxidized and may have been green. This suggests that both of them are also meant to represent yin (white) and yang (usually green, but red is also a yang color)."[34] Chen has tried several times to photograph and preserve this fresco. Beyond its significance as art of Eastern philosophies, the fresco is important, Chen wrote, because "it relates to my childhood memory. In my hometown (Hunan Province) in my family's age-old house where I was born, there is this kind of diagram of taiji on the roof beam of our hall. For me, it is not only the diagram

32
Information received on February 26, 2006 from http://www.chinesefortunecalendar.com/yinyang.htm. Web site copyrighted by Allen Tsai. The philosophy of the *Yi jing* (Book of changes) can be traced to the Western Zhou dynasty (c. 1050–771 B.C.) The *Yi jing* is one of the Chinese classical texts put forward by the philosopher Confucius from preexisting ideas and rituals in order that traditions not be lost. The others were the "*Book of Songs*, which contains ritual hymns…, the *Book of Documents*, which has ritual prayers, announcements, invocations, calendars, and drama texts, the *Book of Rites* (now lost), which has the scripts of ritual performances, the *Book of Changes*, which has the oracle texts for the divination in relation to sacrifice, and the *Chunqiu*, which records events at which major sacrifices were performed." Kristofer Schipper, "Taoism: The Story of the Way," in Little, *Taoism and the Arts of China*, 54.

33

The fort at Zhenbeitai Pass was built in about 1472. The forty-four caves of various sizes at Hongshixia date back to the Tang dynasty (A.D. 618–906), with inscriptions, reliefs, and clay and stone sculptures from many periods, but many were damaged or destroyed in the Cultural Revolution. Information received on March 23, 2006, from http://www.chinavr.net/shaanxi/yulin/hongshixia.htm.

34

Shawn Eichman, e-mail to Christine Starkman, April 10, 2006. Eichman also noted that "yin and yang are usually depicted by an opposing white tiger (yin) and green dragon (yang). At the same time, Chinese tigers are sometimes virtually indistinguishable in form from dragons, or on the other hand it wouldn't be inconceivable to have yin and yang in this case represented by two dragons, as circling dragons are a common motif for the ceiling wells at Yulin." The eight three-line images in the center are called Eight Trigrams. These sets of lines, some of which are broken (representing yin) and others of which are unbroken (representing yang), are used to explain "all that happens in heaven and on earth." The Trigrams were expanded into sixty-four six-line combinations known as hexagrams. With these, a system of prognostication was devised, based on a mathematical game. The hexagrams ideally represent all of the possible and forever changing combinations of yin and yang forces in the uni-

verse. See also Schipper, "Taoism," and Stephen Little, "Heaven and Earth: Daoist Cosmology," in Little, Taoism and the Arts of China, 139. "As one of four creatures of the world's directions, the dragon stands in the East, the region of sunrise, of fertility, and of spring rains. One depiction, which began to appear in the plastic arts in the Tang dynasty, shows two dragons playing in the clouds with a ball or a pearl (=thunder), therefore causing rain. The dragon-and-pearl motif is generally found on silk robes and bronze mirrors." Wolfram Eberhard, A Dictionary of Chinese Symbols: Hidden Symbols in Chinese Life and Thought, tr. G. L. Campbell (London: Routledge & Kegan, 1996), 83–85.

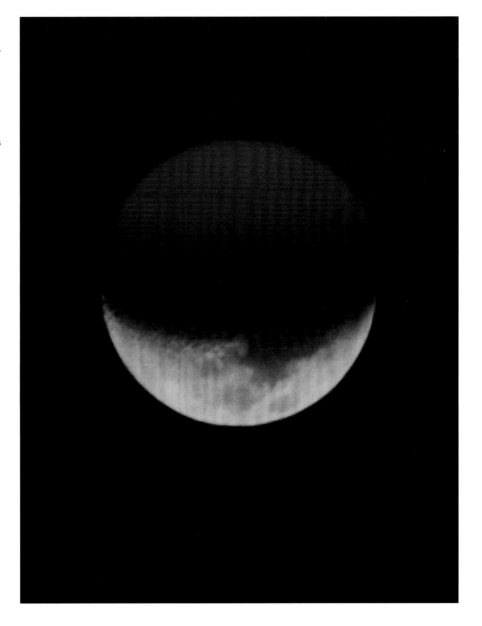

Fig. 9

RI YUE [Sun Moon]
YANTAI, SHANDONG PROVINCE, 1985
Chromogenic photograph

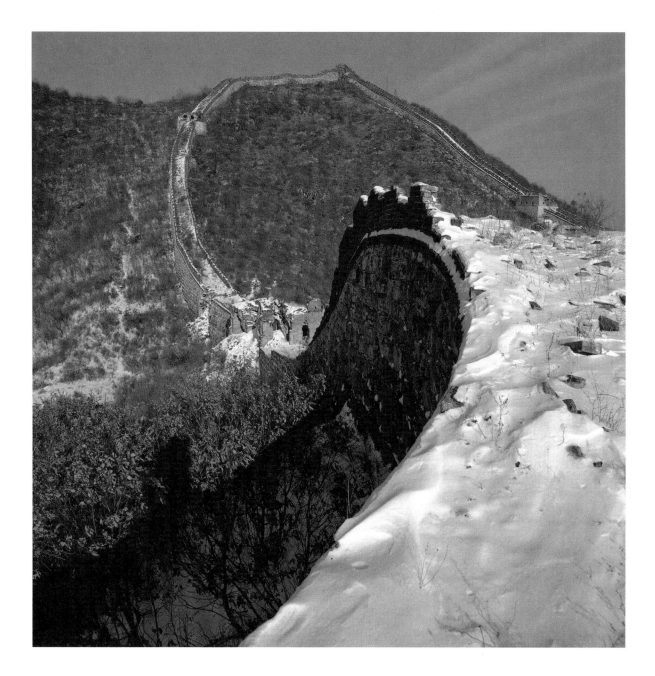

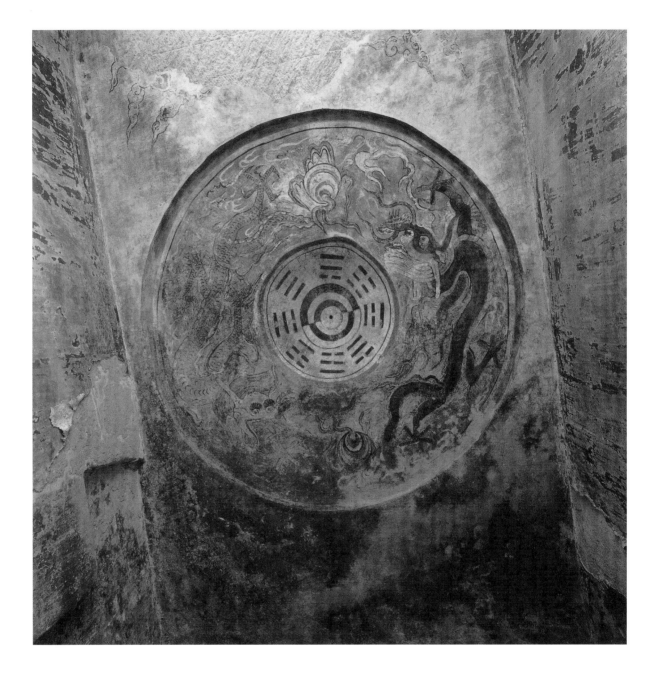

carved or painted on our Chinese age-old private residences, temples, and other structures, but also a totem. It symbolizes peace and safety, balance, harmony, and coordination."[35] Chen was driven to make this photograph because he was equally afraid that weather and time would damage the fresco further or that it would be restored to the point that would lose all sense of antiquity. After photographing the fresco, he lit incense, prayed, and left a donation.

When Chen began to make black-and-white photographs using an 8 x 10 inch camera, he entered a third phase of his photography, one that he explains by citing a poem that has been cited as Daoist and as Zhen Buddist.[36]

Seeing a mountain as the mountain;
The mountain was not the mountain;
Seeing the mountain as a mountain[37]

He relates the first line to his 35mm work, which was mostly reportage. He accurately conveyed the appearance or the shape of the mountain and how the Wall looked as it moved over the surface of the mountain, but each mountain was any mountain. In Daoist terms, he was guided by a received understanding of the definition of a mountain (and of the Great Wall). What he saw was guided mostly by first impressions and by what he previously knew mountains and the Wall to be. At this stage he did not have much personal experience with the Wall. These pictures are descriptive, but not expressive.

In the second phase he realized, as every serious photographer does, that each individual picture must have a specific perceptual and emotional core. He worked past his learned understanding of mountains in favor of his own insights into the scenes before him. Chen relates the poem's second line to the color images that he made with the 2¼ inch square negatives. These images, which are the ones most shaped by his visualization of what the photographs should convey, are more personal observations. They are still guided by concepts, but the concepts are his formulations. Compared to his early photographs and his 8 x 10 inch black-and-white work, these color pictures are more dramatic because of the atmospheric

35
Chen Changfen, e-mail message to the author, March 4, 2006.

36
Chen wrote, "From the historical point of view, Zhen and Dao shared inseparable origins, hence the saying 'Buddhism, Daoism— the same family (Fo Dao Yi Jia).' My relation to both is more philosophical than religious." Chen Changfen, e-mail to author, April 12, 2006.

37
Jian Shan Shi Shan
Jian Shan Bu Shi Shan
Jian Shan Hai Shi Shan

38
He was quick to say that he had no access to the history of photography in books or exhibitions from the time of the founding of the People's Republic until very recently. He knew the work only of select other photographers in China. In the past few years he has met other photographers, such as James Nachtway, whom he admires very much. See also his remarks in his interview published in this book.

39
Chen's winter pictures are pale, with snow and ice obscuring the Wall's path and its environs. Snow and mist in all seasons reduce visibility down to the next peak and dematerialize the great stone face of the mountains.

40
François Cheng and Najal Tad-
jadod, "The Sound of Silence—
Chinese Painting—Between the
Visible and the Invisible," UNESCO
Courier, December 1990. Also
accessible online at http://www.
findarticles.com/p/articles/mi_m1
310/is_1990_Dec/ai_9339038#.
　See also McMahon, "Sign
System in Chinese Landscape
Paintings," 64–76.

41
For an analysis of wu xin see
Cheng Zhu, "Fording River With-
out Wetting Feet: Tacit Knowl-
edge in Taoism and Its Influence
on Chinese Culture," http://
gseweb.harvard.edu./~t656_web/
Spring_2002_students/zhu_cheng
_taoism_tk.htm. Information
received February 26, 2006.

42
Information received on March
12, 2006, from http://www.
chinapage.com/gnl.html.
Tao Te Ching, tr. Peter A. Merel.

43
Information received March 10,
2006, from Kelley L. Ross, Com-
ments on Tao Te Ching, http://
www.friesian.com/yinyang.htm.
Chapter 7 of Tao Te Ching, tr. D.
C. Lau (New York: Penguin, 1963).

conditions that he photographed, as well as the pyrotechnical effects of light on clouds, ice, sand, and weathered stone. The shifting colors of the seasons and climatic conditions, in concert with his deepening perceptions of the Wall, afford a great variety of insights. In recent years Chen has toned down the drama of these pictures by printing them on rice paper, making the colors more subtle than those reproduced on smooth, glossy paper and making them less like the surfaces of magazines and book illustrations. He prefers the way the photographic inks are absorbed into the rice paper, stylistically linking them more directly to Chinese painting.

When asked about the influences of other artists, Chen cites Chinese painters and calligraphers rather than other photographers.[38] Like Chinese painters in the centuries before him, most specifically Bada Shanren (1626–1705) of the Qing dynasty, Chen sometimes leaves large areas of his pictures blank, with no photographic detail. He uses white mists and dense black shadows to create striking voids in his picture (plates 13 and 14).[39] In the tradition of Chinese painting, the unpainted void is not a negative space but a positive one. It is not empty, but full. It is the space of the indefinable, a link to the invisible world, a symbol of life and power, and a place where the viewer's imagination is offered room to wander.[40]

Philosophically, Chen's third phase of development is related to a larger grasp of the concept of emptiness, what Daoism refers to as "no knowledge" (wu xin) and "no action" (wu wei).[41] These expressions relate directly to Chapter 7 of the Yi jing:

> Nature is complete because it does not serve itself.
> The sage places himself after and finds himself before,
> Ignores his desire and finds himself content.
> He is complete because he does not serve himself.[42]

A different translator restated this as "the Sage puts his person last and it comes first…without thought of self that he is able to accomplish his private ends."[43] If someone pursues his self-interest (practices the "doing" of self), he defeats and destroys it. By practicing "no action" the sage therefore allows the Dao to pursue his self-interest for him. This was further explained

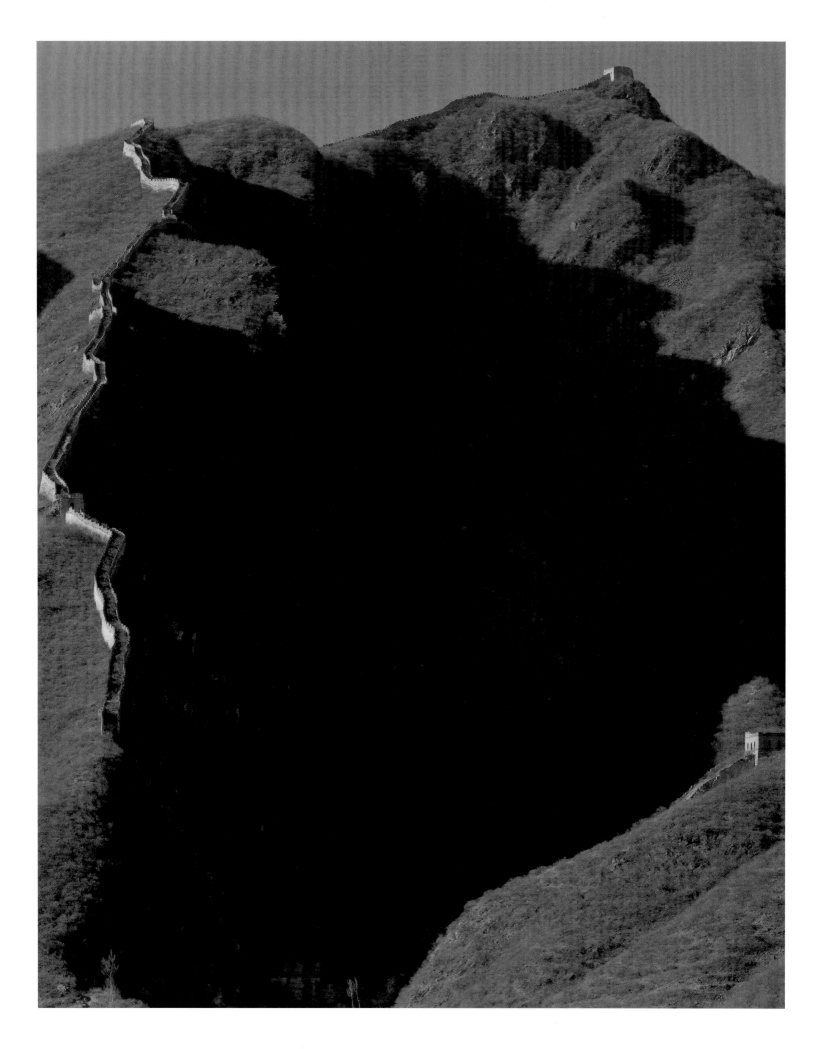

Plate 13 XIDALOU, BEIJING, 1998, gelatin silver photograph [checklist 34]

Plate 14 JIANKOU, BEIJING, 2000, gelatin silver photograph [checklist 56]

by Professor Kristofer Schipper: "Only those who know that they do not know can, by uniting with nature and rediscovering spontaneity, through nonaction (*wu wei*), intuitively grasp the underlying truth of all that is. In grasping and holding on to this truth, they become one with it and thus 'obtain the Tao.'"[44]

In the third phase Chen has a deeper understanding of his religion in relation to the practice of his art. As a Western art historian, it is difficult for me to explain the process. I cannot say it is his goal or pursuit, because that would only assure futility within the precepts of Daoism. Chen rejects the concept of "pursuing a life of contemplation," or of any pursuit. The Dao way is wu wei—pursuit without pursuit. Having no goal leads to finding the way. Perhaps I can best describe it as a state of mind that has yielded the newest images. Another consequence of accepting wu wei is that Chen no longer will participate in competitions.[45] The American photographer Robert Adams described other photographers' working methods in a similar way without putting it in Daoist terms. "When photographers get beyond copying the achievements of others, or just repeating their own accidental first successes," Adams wrote, "they learn that they do not know where in the world they will find pictures....Each photograph that works is a revelation to its supposed creator. Yes, photographers do position themselves to take advantage of good fortune, sensing for instance when to stop the car and walk, but this is only the beginning. As [poet] William Stafford wrote, calculation gets you just so far—'Smart is okay, but lucky is better.'"[46] Adams and other photographers agree that the best pictures come from being prepared, and then being open to the unexpected. Too much preparation and predetermination of what a picture should convey can be deadly. And at times, the "luck" that artists experience seems divine. For instance, the novelist Walker Percy once said that he was convinced that occasionally, when he was stuck while writing, God told an angel to "throw the bum a sentence."

Some places and people have such powerful histories and entrenched public personas that they are difficult to employ as a subject for art. As I noted above, the artist must both accept and, in some way, shift our perception of something so familiar. This is true when the subjects are celebrities, people who usually work to fix and entrench certain public perceptions

44
Schipper, *Taoism*, 35.

45
He also speaks of the 8 x 10 inch camera as being connected to the structure of his body, of it having a spirit and being capable of dialogue with him. There is precedent for this description in Chinese painting. Art historian Cheng Zhu cited Wu Zhen (1280–1354), "a Taoist and one of the four most celebrated painters of the Yuan Dynasty, [who] described his experience in painting, 'when I begin to paint, I do not know that I am painting; I entirely forget that it is myself who holds the brush.'" Information received February 26, 2006, from http:// gseweb.harvard.edu./~t656_web/ Spring_2002_students/zhu_cheng _taoism_tk.htm. Zhu is citing Da Liu, *The Tao and Chinese Culture* (New York: Schocken, 1979), 65.

46
Robert Adams, "Colleagues," in *Why People Photograph: Selected Essays and Reviews by Robert Adams* (New York: Aperture, 1994), 15–16.

47
John Szarkowski, *Looking at Photographs: 100 Pictures from the Collection of The Museum of Modern Art* (New York: The Museum of Modern Art, 1973), 64.

48
Maria Morris Hambourg, "The Structure of the Work," in John Szarkowski and Maria Morris Hambourg, *The Work of Atget*, vol. 3: *The Ancien Régime* (New York: The Museum of Modern Art, 1983), 23.

and to avoid others. It is also true of subjects typically classified in stereotypical ways: babies, animals, particular professions, and even some colors. And it is true of architecture that has been given national, or even international, status. The Eiffel Tower, the Statue of Liberty, Big Ben, the Sphinx, and the Great Wall of China all claim this rank. Endlessly reproduced as miniature sculptures and on stamps, posters, and T-shirts, these structures are intrinsically linked to their respective nations, but their specific meanings have been stripped away in the haze of familiarity that prevents us from seeing them with any clarity. The third line in the aforementioned poem refers to working past this numbness of vision and then beyond a strong personal vision to a profound openness to the visual world as it presents itself. In his black-and-white 8 x 10 work, Chen has achieved a wholeness whose parts are lost in a seamless realization—*Zhen*, in Daoist terms.

Other photographers known for this heightened, poetic, and difficult-to-describe style of photography include Eugene Atget (1857–1927), Walker Evans (1903–1975), and Robert Adams (born 1937). In their pictures there are no dramatic narrative moments or clear focal points to which our eyes are always first drawn; the pictorial elements are seemingly of equal intellectual and aesthetic weight. All of these photographers use large-format cameras and are best known for subjects with which they worked for long periods of time. Paris and its environs were Atget's subject for three decades. In writing about Atget's work, curator and photographer John Szarkowski described an evolution of aesthetic priorities that is very close to Chen's own. "Other photographers had been concerned with describing specific facts (documentation), or with exploiting their individual sensibilities (self-expression)," wrote Szarkowski. "Atget encompassed and transcended both approaches when he set himself the task of understanding and interpreting in visual terms a complex, ancient and living tradition."[47] Curator Maria Morris Hambourg, Szarkowski's collaborator in chronicling Atget's prolific career, referred to Atget's "willingness to forget what he knew in the face of what he saw."[48] Similarly, in a dry, measured style, Evans has immortalized bits of American vernacular culture that otherwise we would not have even noticed, and Robert Adams has repeatedly traversed sections of the American West, especially the prairies of

Colorado and the shorelines and forest of Washington state, paying close attention to "the world as it is."[49]

Another photographer who shared Chen's commitment to a specific place was the American landscape photographer Ansel Adams (1902–1984), who made thousands of negatives in his home state of California, the majority of which were made in Yosemite Valley or in the High Sierra to the east of the valley. As Szarkowski observed, "Yosemite and the High Sierra constituted the place he knew and loved best....We might think of it as the source of his sanity and his strength."[50] Yosemite was to Adams what Jiankou is to Chen, a place to which he could return again and again to photograph. Adams repeatedly and variously photographed popular sites within Yosemite, such as Half Dome, El Capitan, and the Yosemite Valley. Also like Chen's approach to Jiankou, Adams returned to Yosemite in all seasons, and he was particularly attuned to the myriad effects of atmosphere and light on weathered stone.

Chen's vision continues to evolve. He has fashioned a 20 x 24 inch camera with which he has begun to work. The panoramic pictures included in this exhibition and catalogue are new, both in format and in vision. His techniques are a blend of traditional and new technologies, and traditional and personal approaches to the subjects. Chen prints the panoramic images on silk and mounts them as scrolls with colorful silk borders. Although Chinese scrolls are traditionally viewed one section at a time as they are unrolled, Chen's panoramas are intended to be seen all at once. Nor are they narrative, telling a story or revealing a journey. Chen's pictures can be approached with equal clarity from either end. "Or," said Chen, "one walks their length as one might walk the actual Wall."[51]

Chen finds comfort in the fact that his pictures preserve views that do not, or soon will not, exist. He also knows that some of his visions capture conditions of light, air, emotion, and perception that existed only at the moment of the exposure on film. He can return to Jiankou time and again because it constantly changes with his perceptions. The American photographer Mark Klett (born 1952), an artist who has repeatedly photographed the same mountainous regions in the American West, addressed this phenomenon recently when he wrote, "Returning is part of the fascination with place. I've come to think that when you return to a place at

49
Robert Adams, *Notes for Friends: Along Colorado Roads* (Boulder: Center of the American West and University Press of Colorado, 1999).

50
John Szarkowski, *Ansel Adams at 100* (Boston: Little, Brown, 2001), 18, 21.

51
Chen Changfen, fax to the author, April 10, 2006.

52
Mark Klett, e-mail message to the author, February 22, 2006.

another time, it's not just the time that is different. I think the place isn't the same either, even if it looks the same. I'm convinced that space and time move together. That means that you can never really go back and that the place is always new."[52] Chen says that the reaction he most wants is that the Great Wall he has photographed is different from the Great Wall visitors have seen. This means he will have succeeded in stripping away in the haze of familiarity around the Wall and will have seen, and helped us to see, exact, unique moments in time and space in ever-changing vistas. And—the Dao willing—each future photograph of the Great Wall will be different from what he has previously seen and preserved.

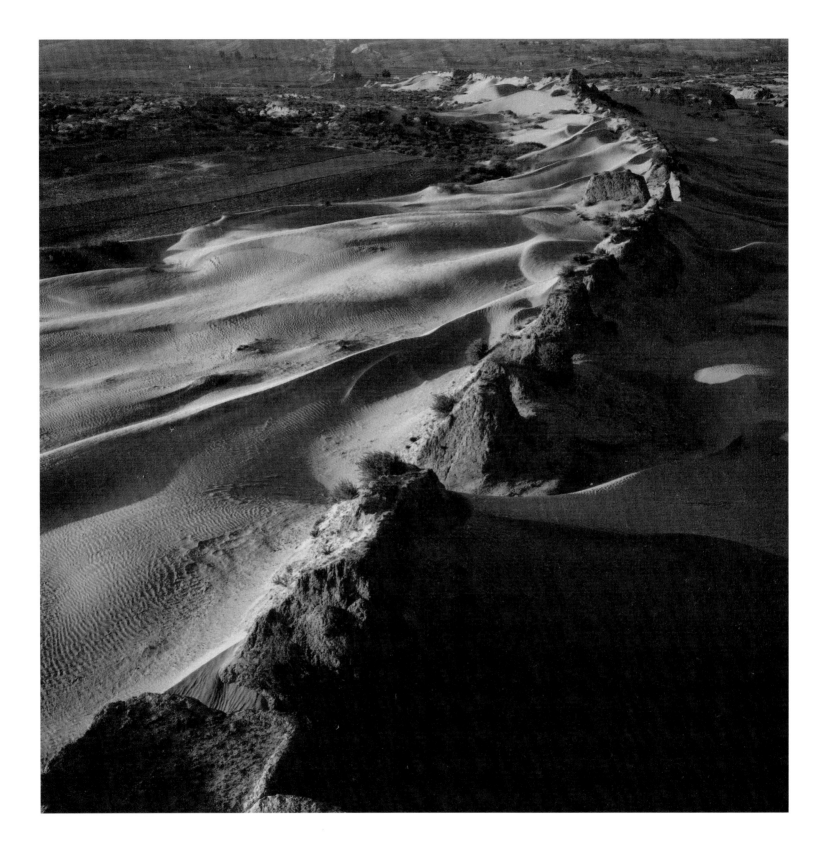

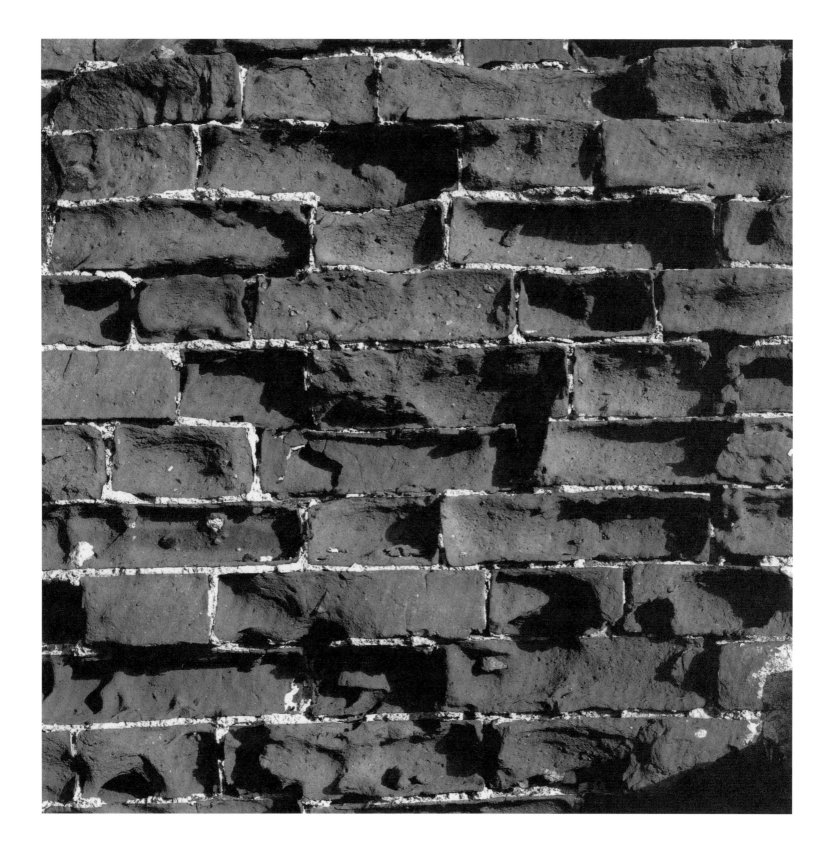

Plate 17 DUNHUANG, YUMENGUAN, GANSU PROVINCE, 1998, gelatin silver photograph [checklist 29]

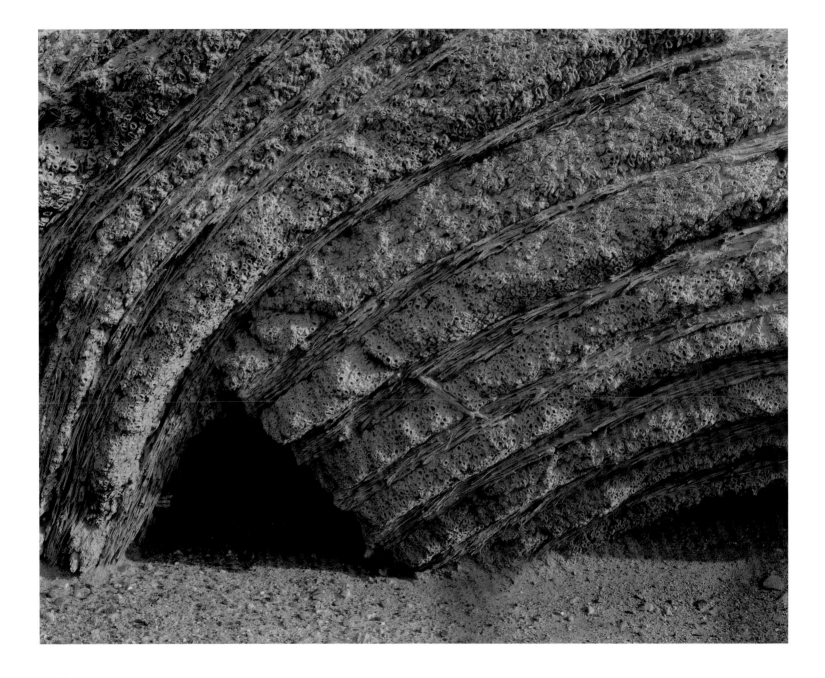

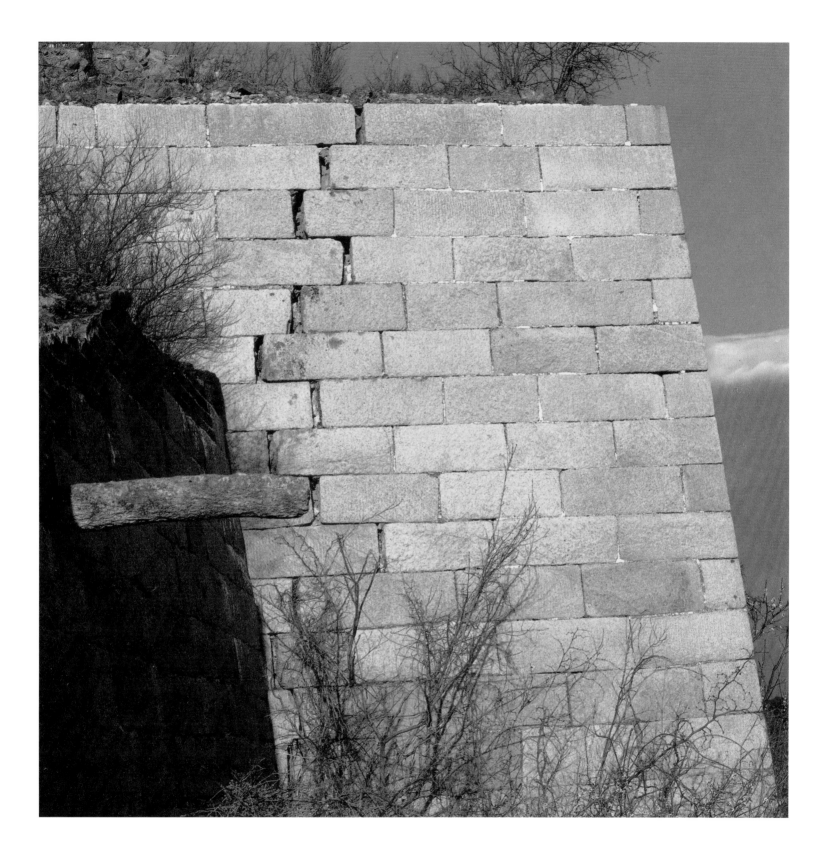

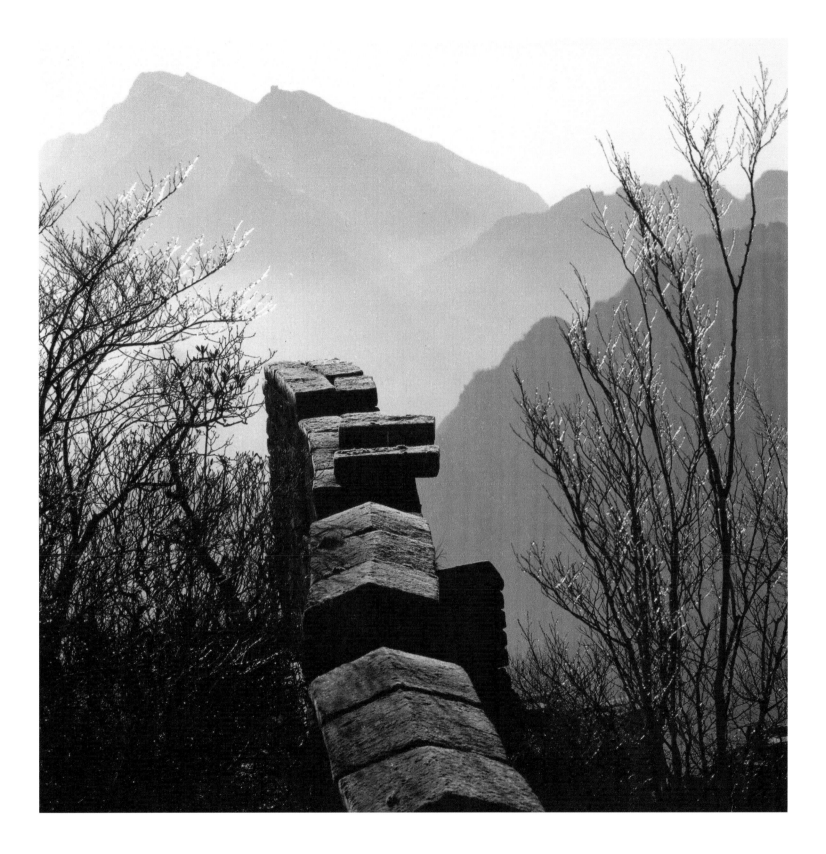

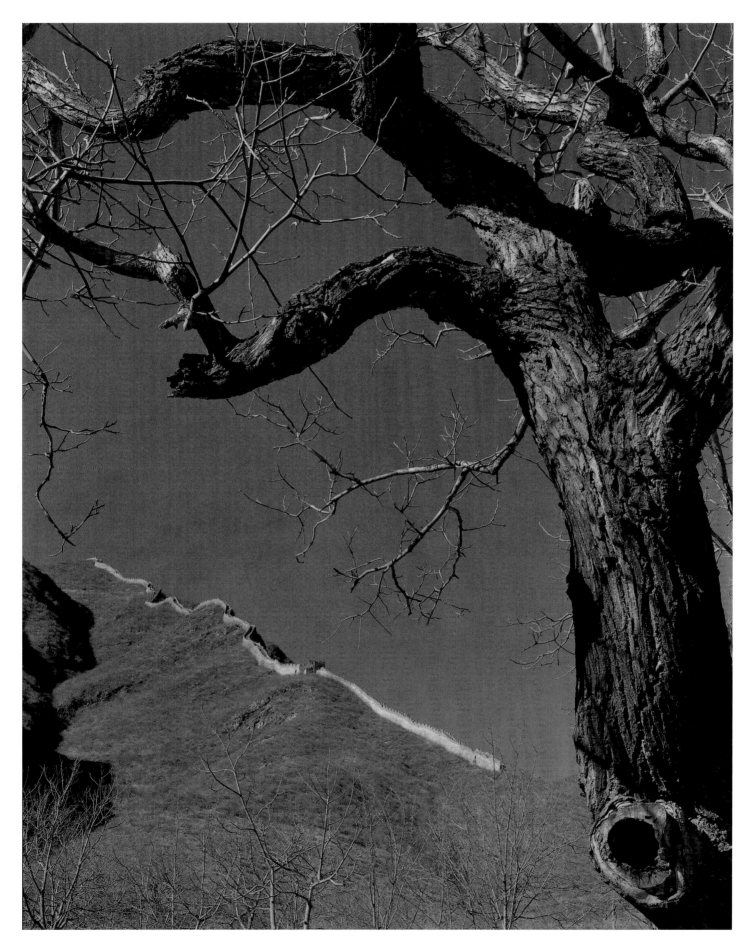

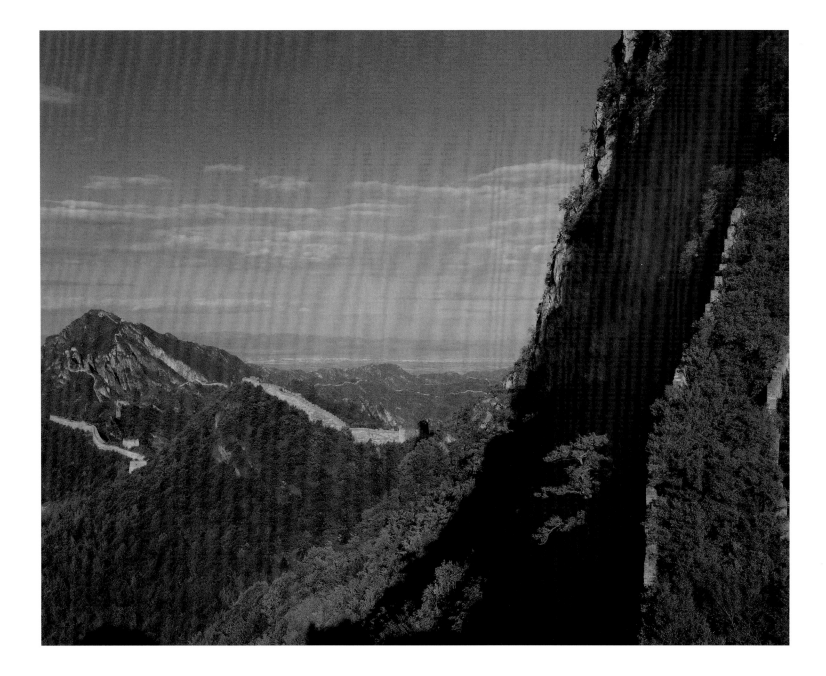

Plate 22 YINGFEIDAOYANG, HEIHUDONG, JIANKOU, BEIJING, 2002, gelatin silver photograph [checklist 38]

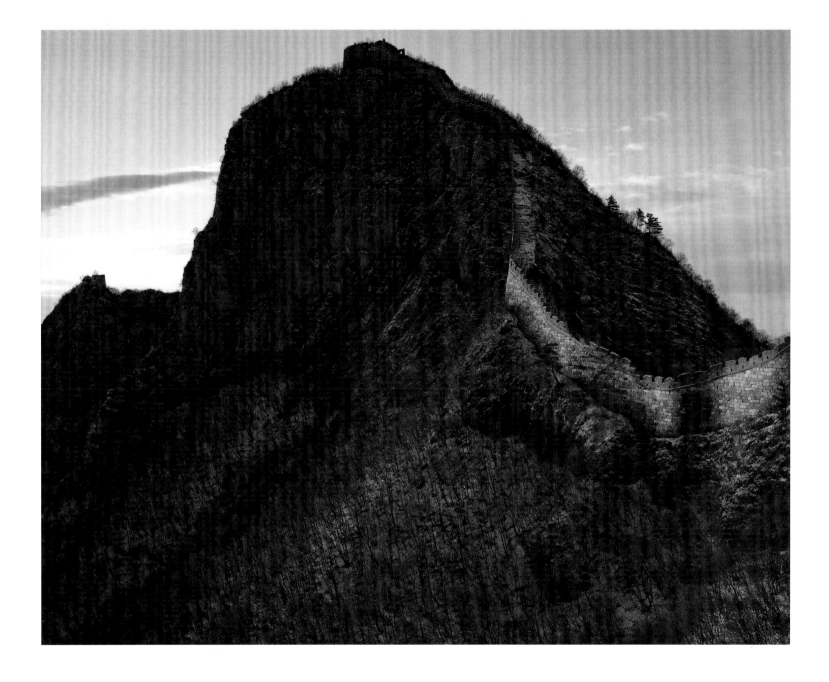

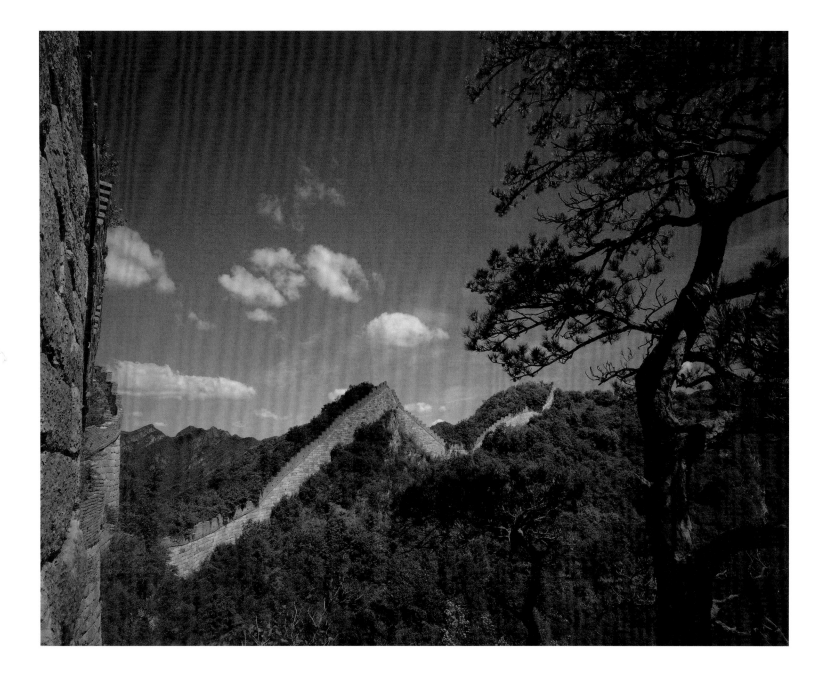

Plate 24 BEIJINGJIE, JIANKOU, BEIJING, 2003, gelatin silver photograph [checklist 41]

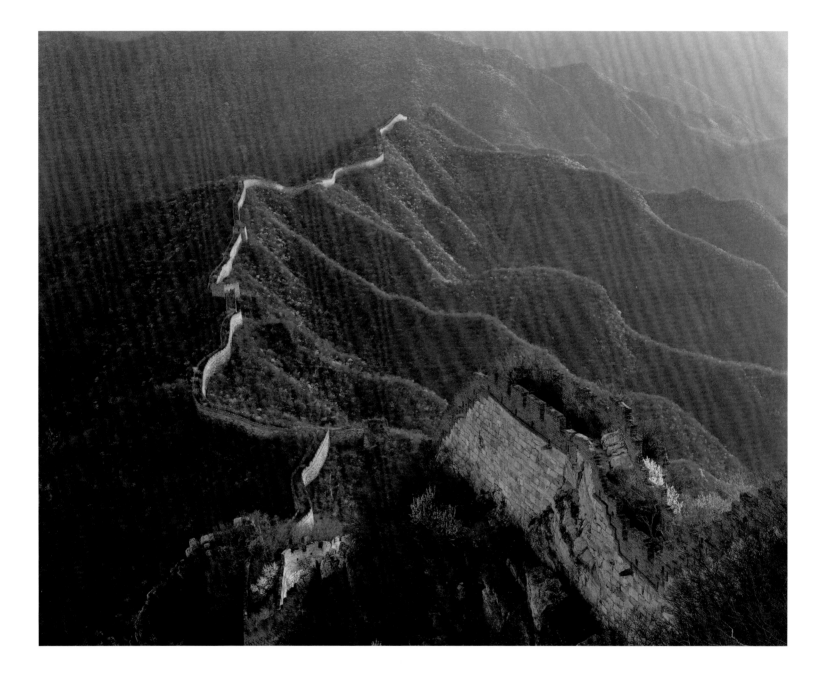

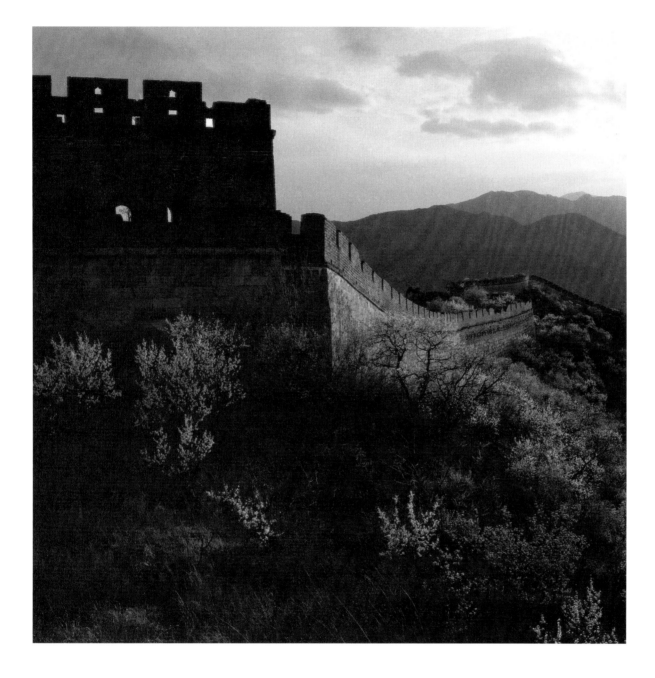

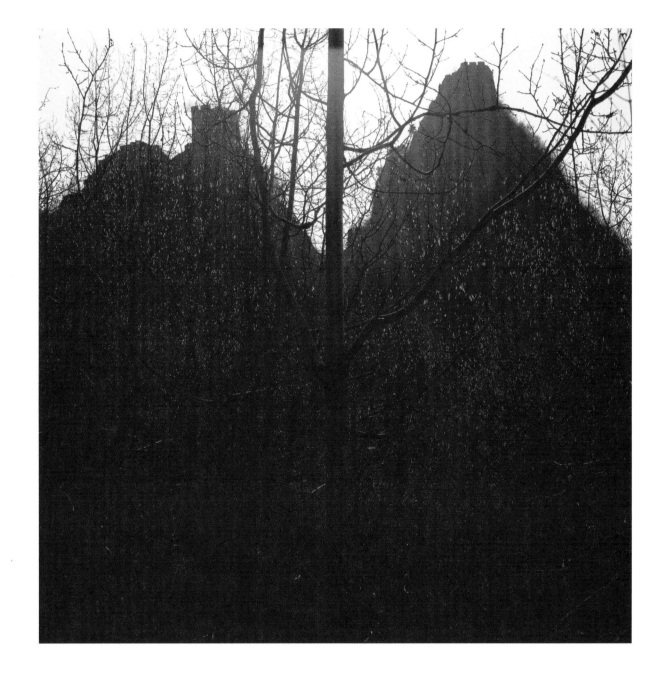

Plate 27 YINGFEIDAOYANG, JIANKOU, BEIJING, 2002, gelatin silver photograph [checklist 44]

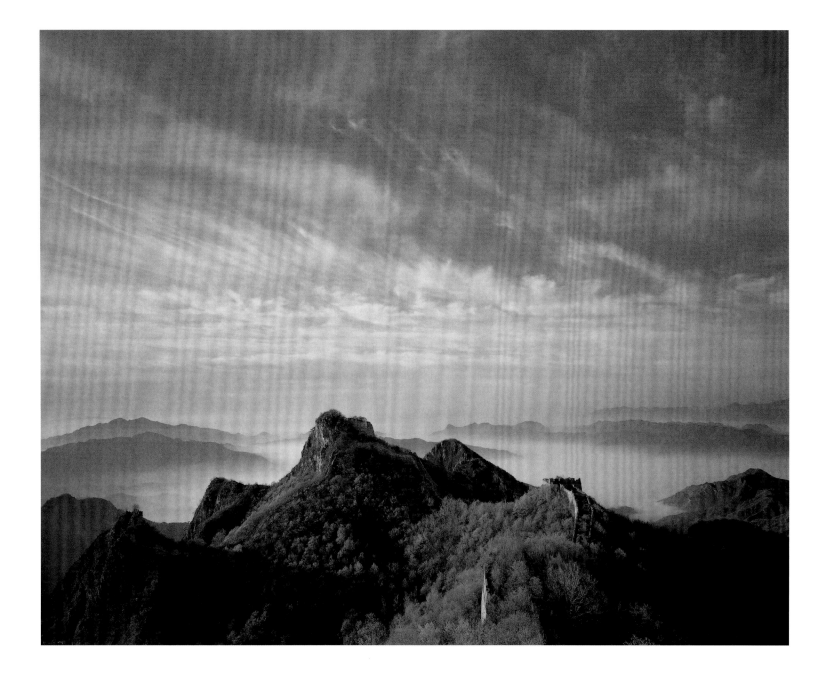

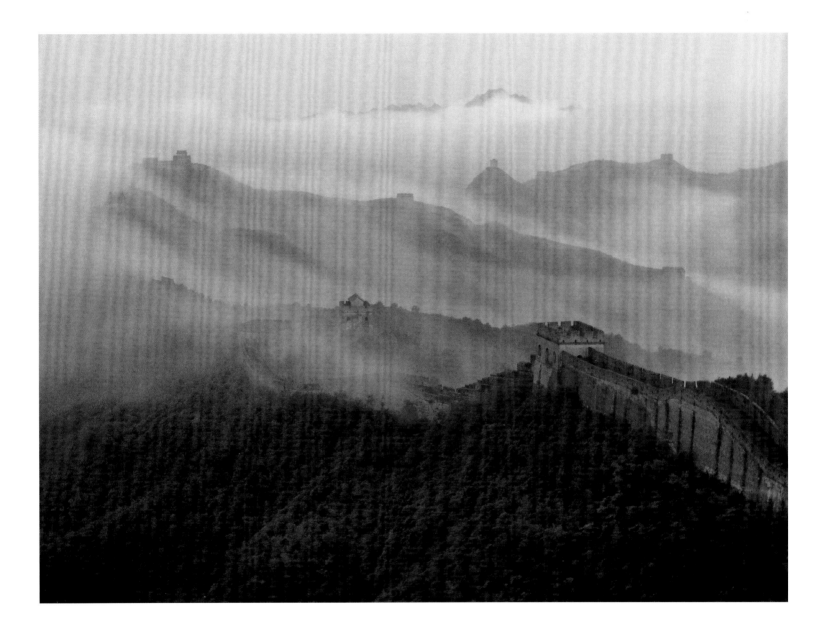

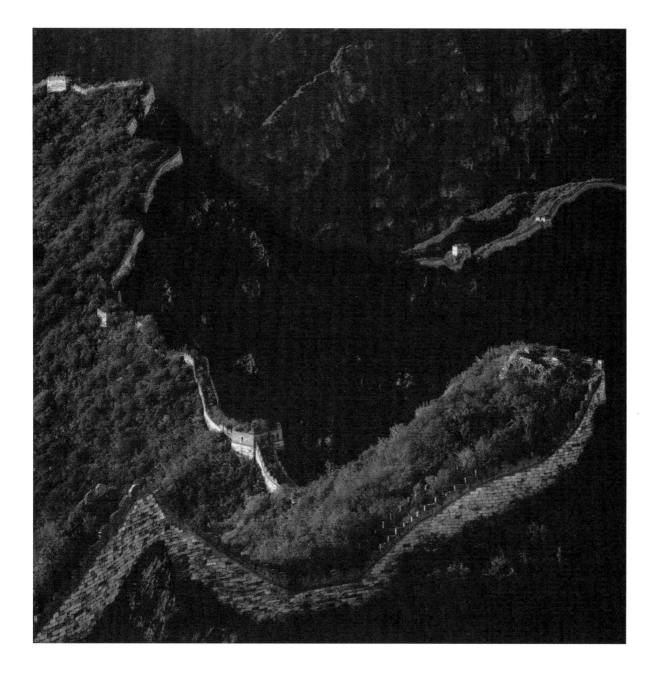

61

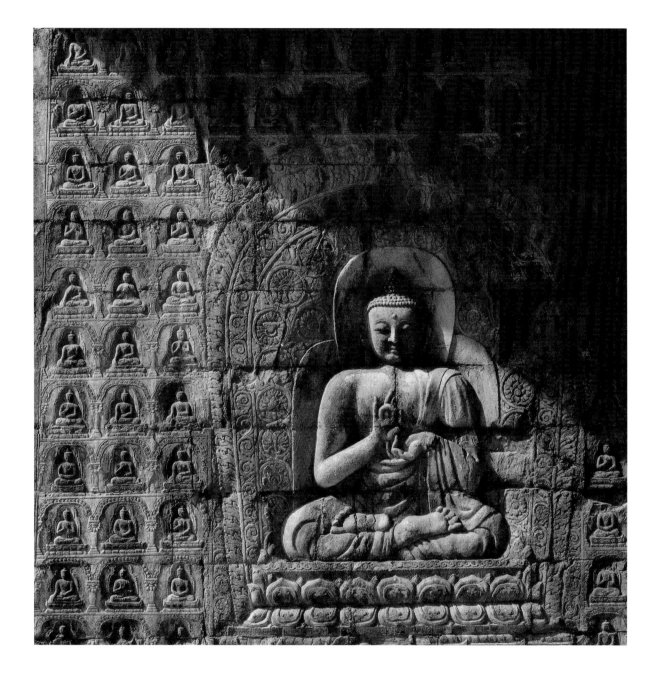

Plate 33 JIANKOU, BEIJING, 1997, inkjet photograph on rice paper [checklist 23]

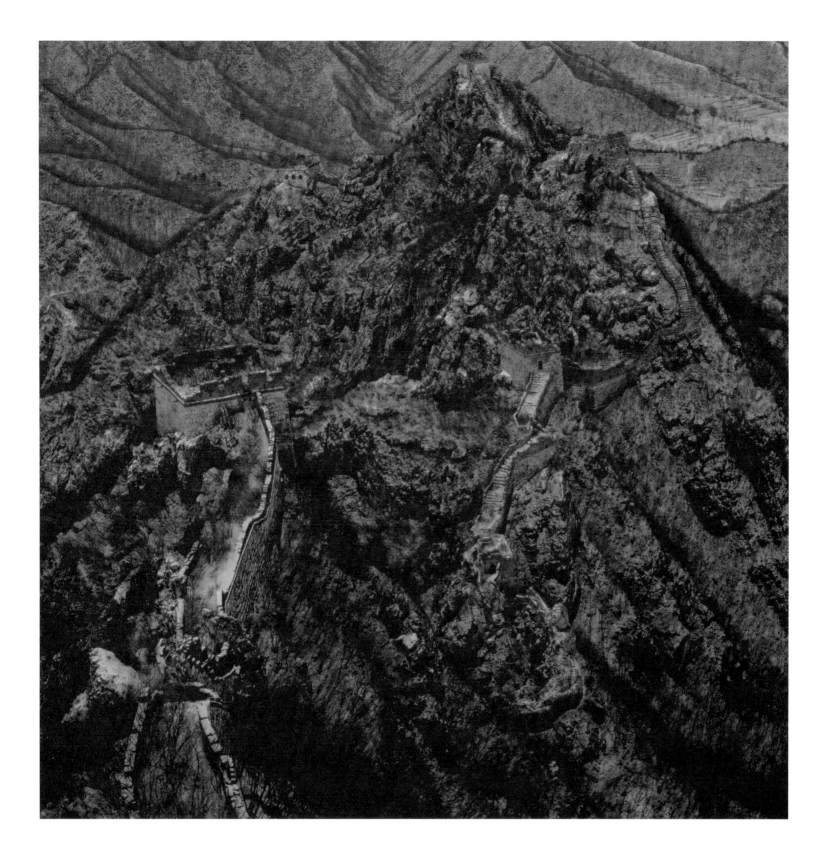

Plate 34 YINGFEIDAOYANG, JIANKOU, BEIJING, 1998, gelatin silver photograph [checklist 46]

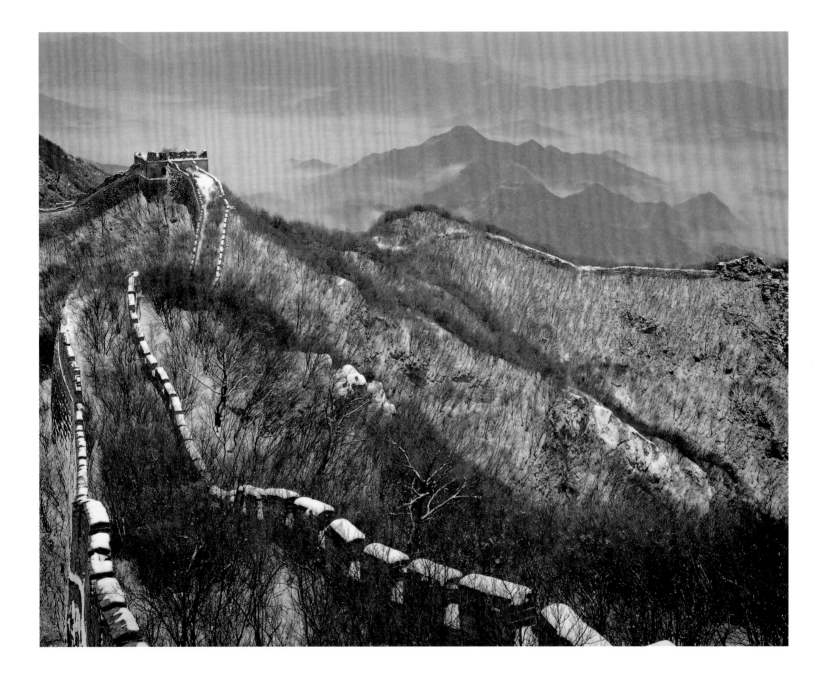

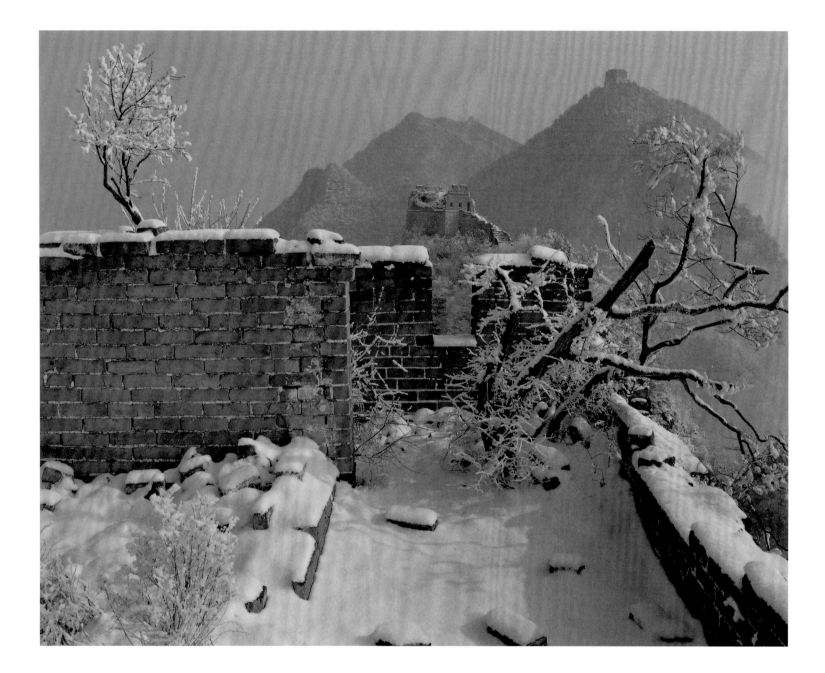

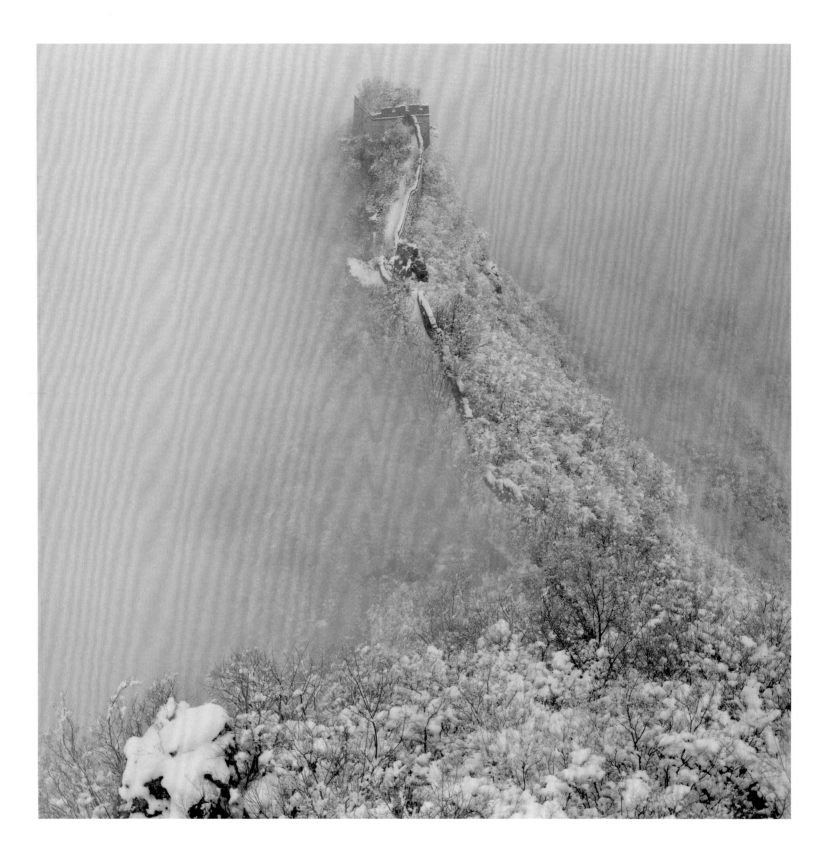

Plate 38 XIDAQIANG, JIANKOU, BEIJING, 1992, inkjet photograph on rice paper [checklist 17]

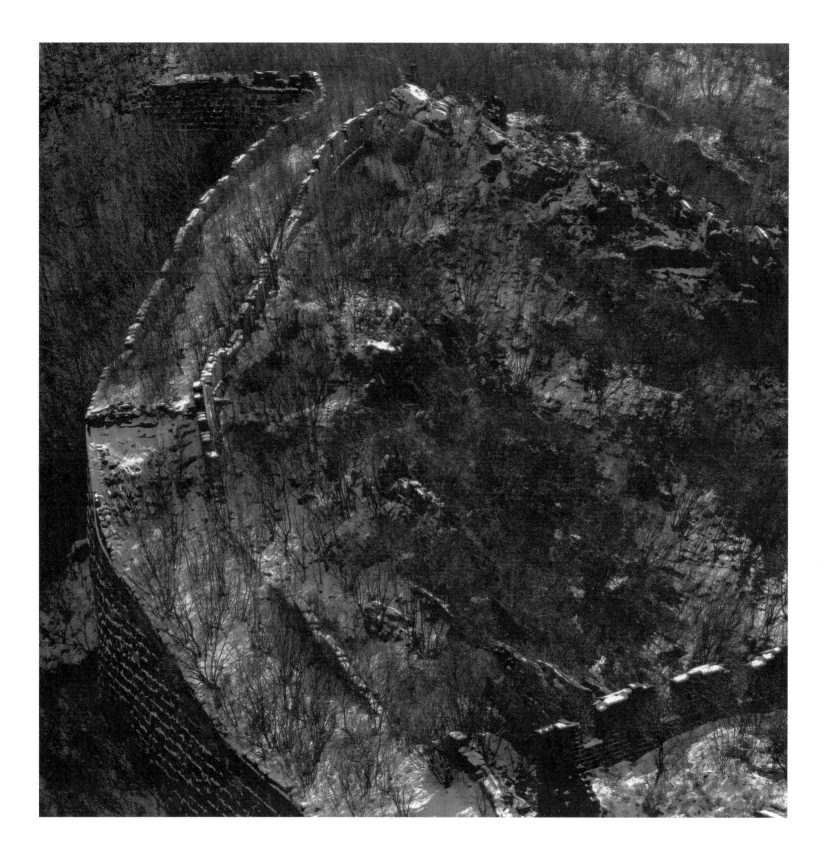

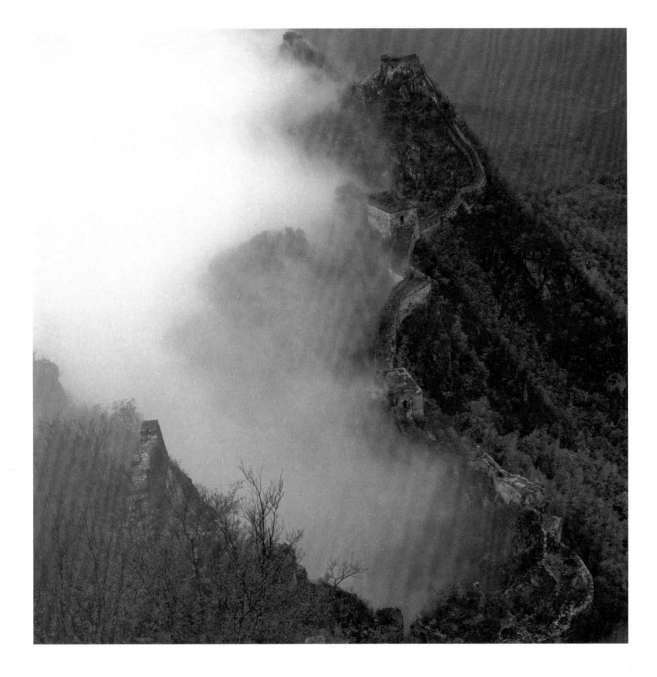

Plate 40 LAOLONGTOU, SHANHAIGUAN, HEBEI PROVINCE, 2000, inkjet photograph on rice paper [checklist 26]

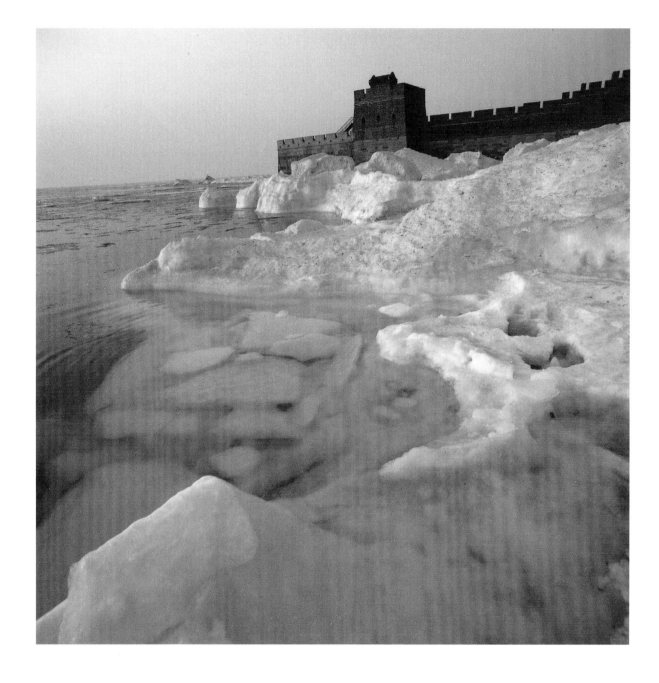

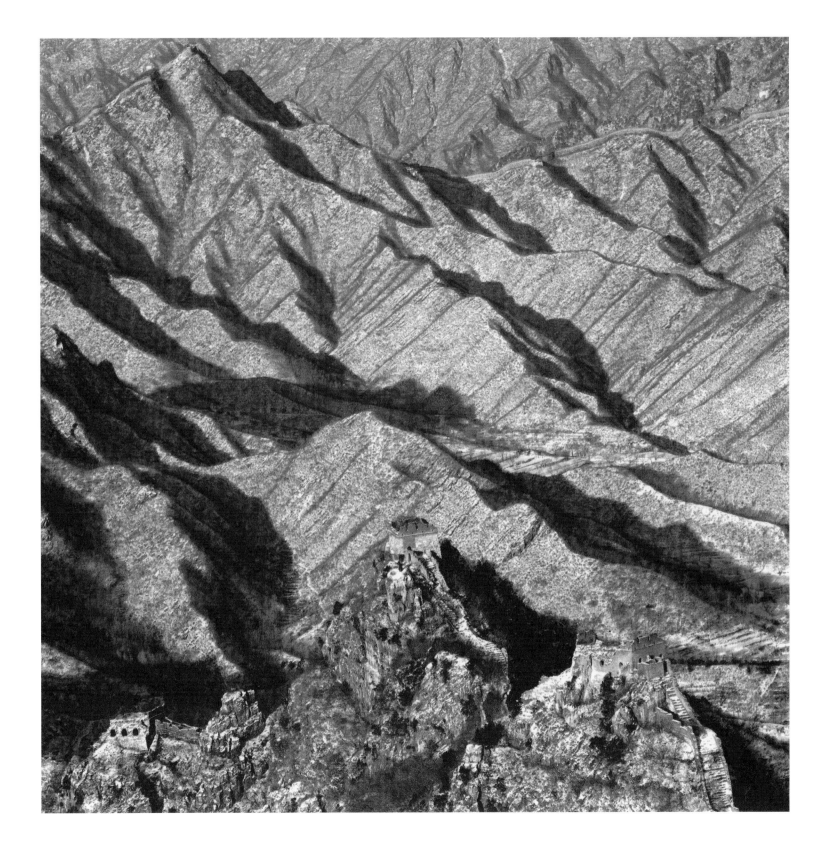

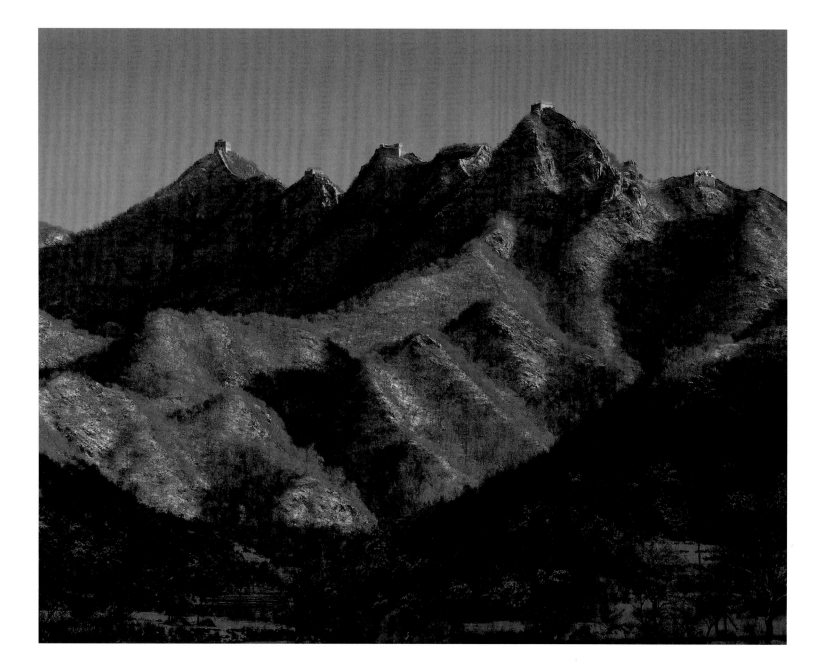

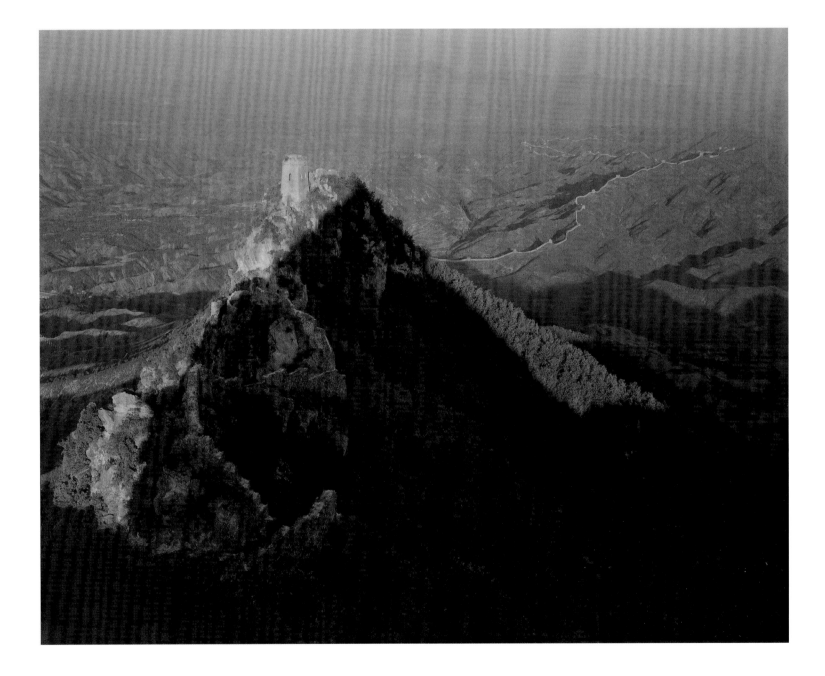

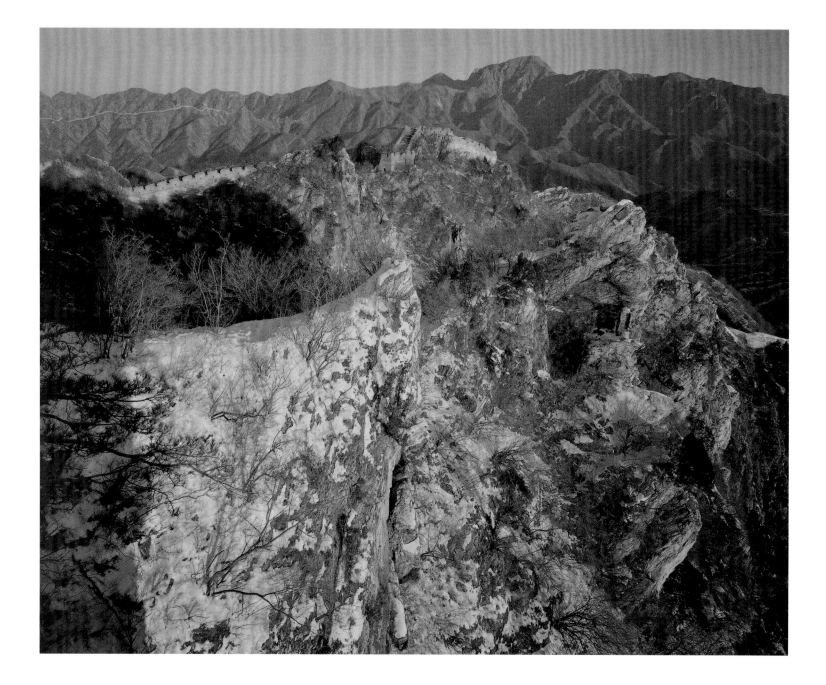

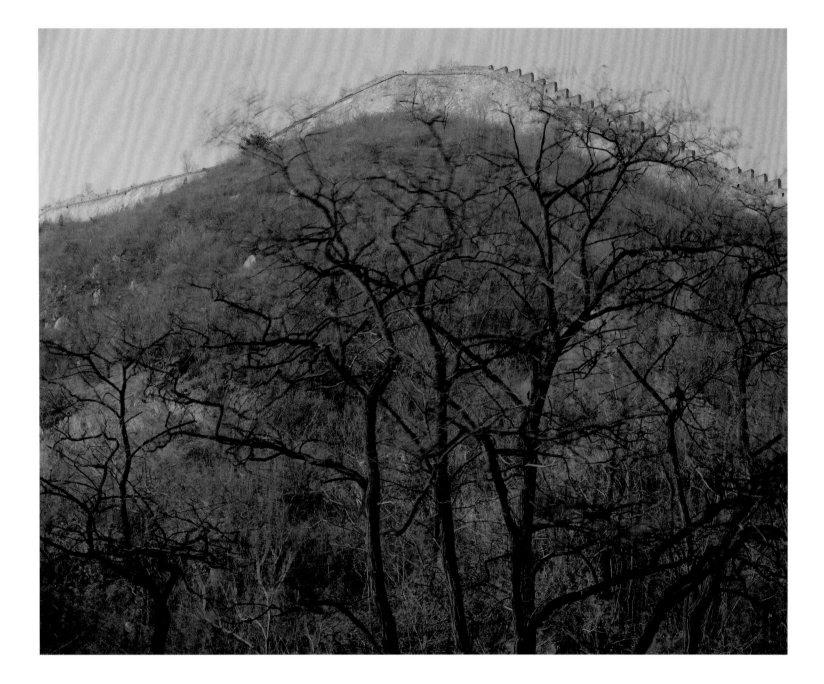

Plate 47 JINSHANLING, HEBEI PROVINCE, 1993, gelatin silver photograph [checklist 61]

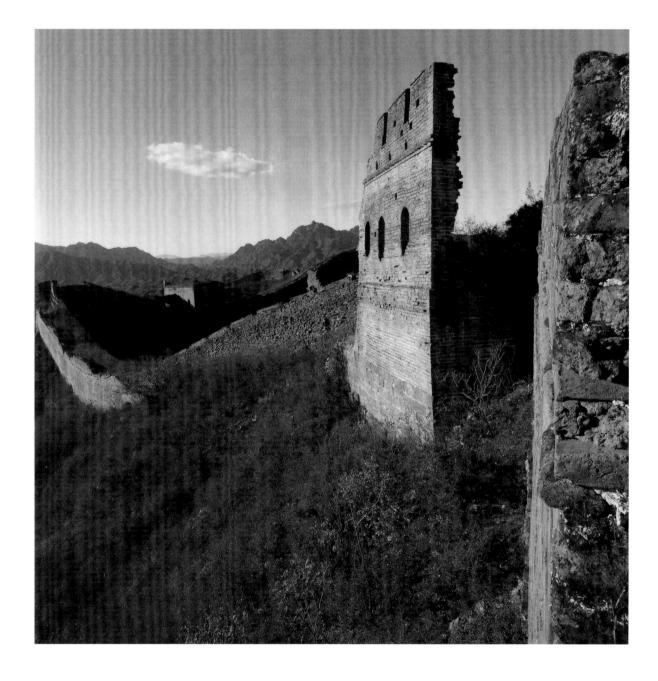

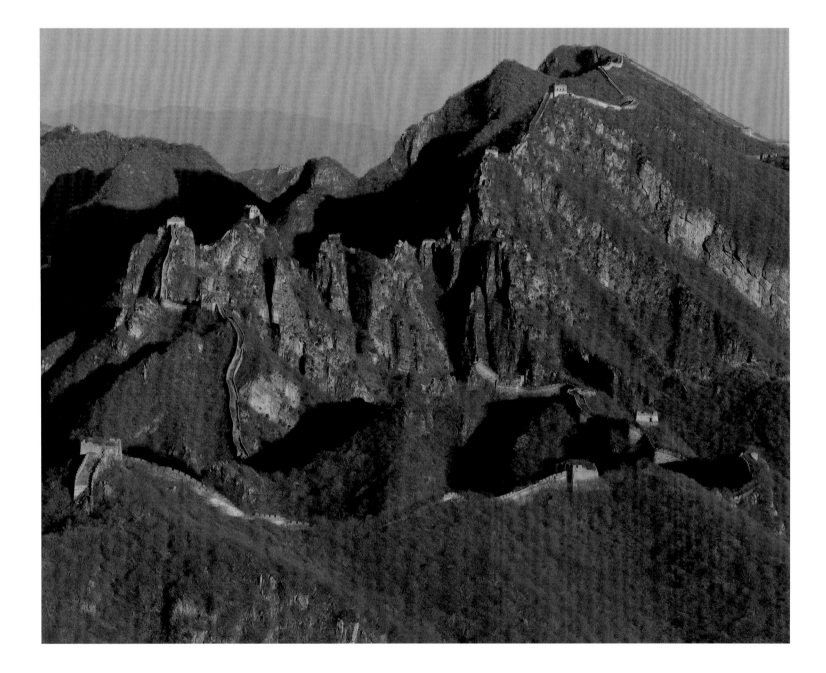

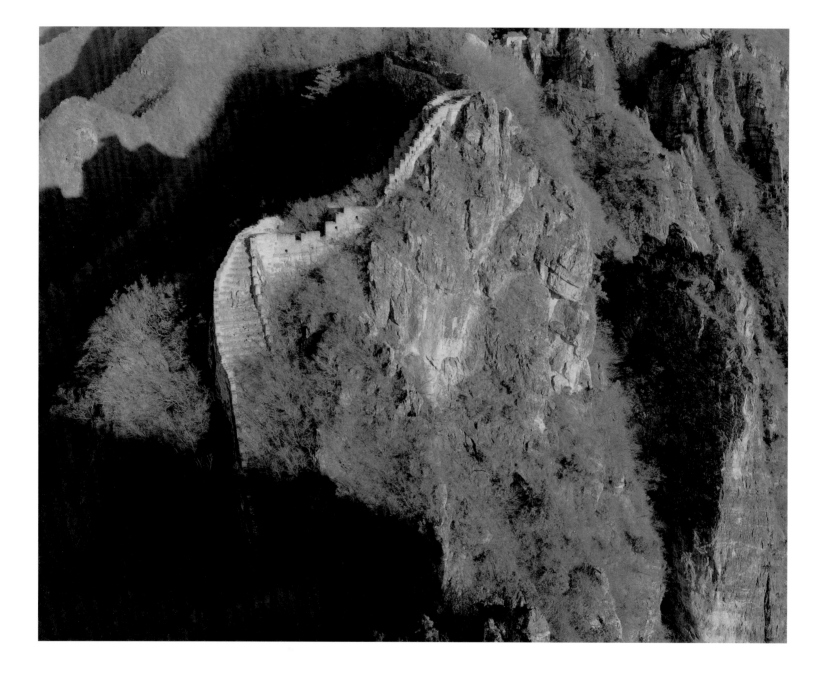

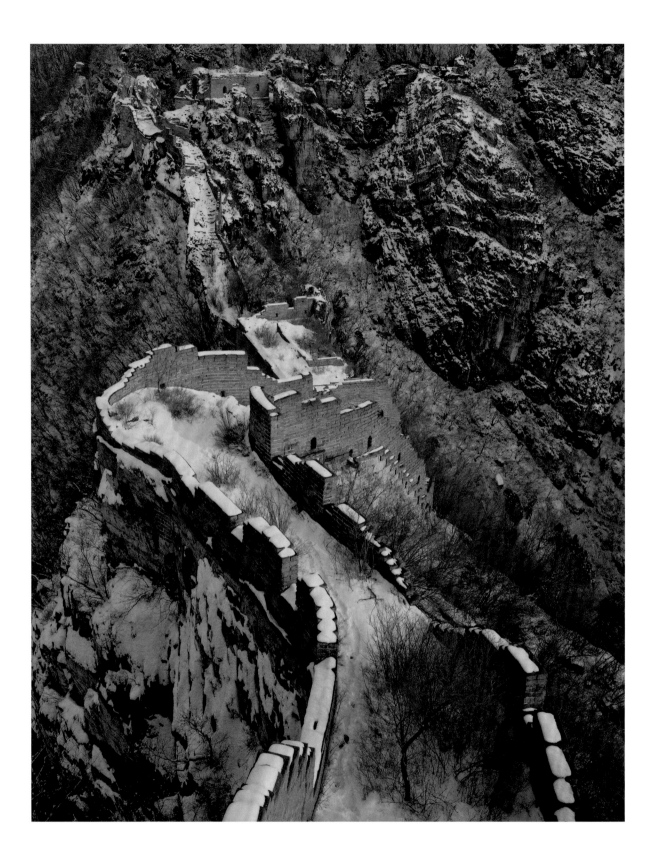

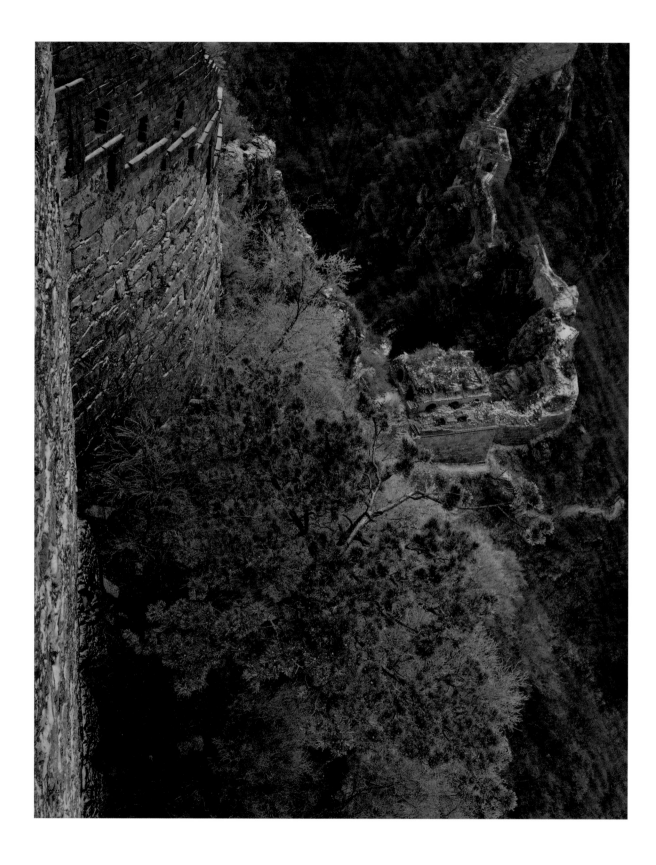

Plate 52 BEICHAKOU, NINGXIA PROVINCE, 2002, inkjet photograph on silk mounted as a scroll [checklist 64]

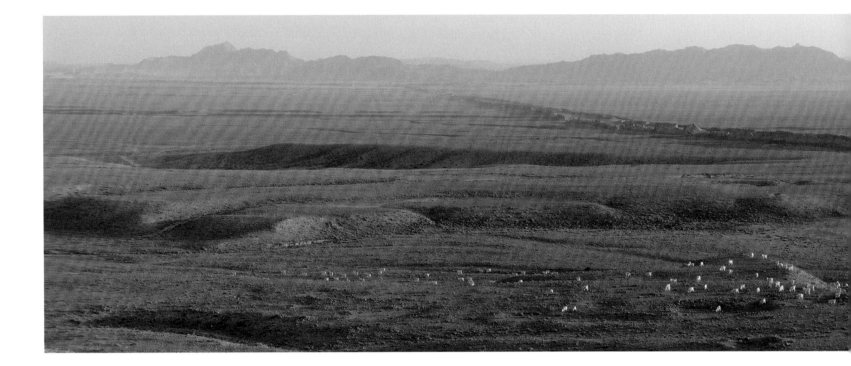

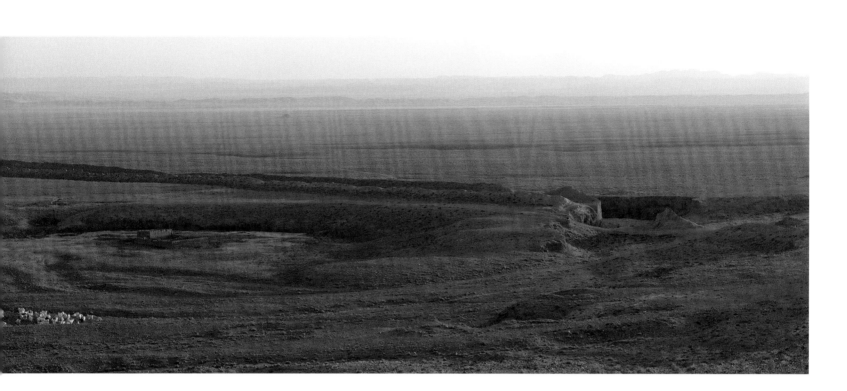

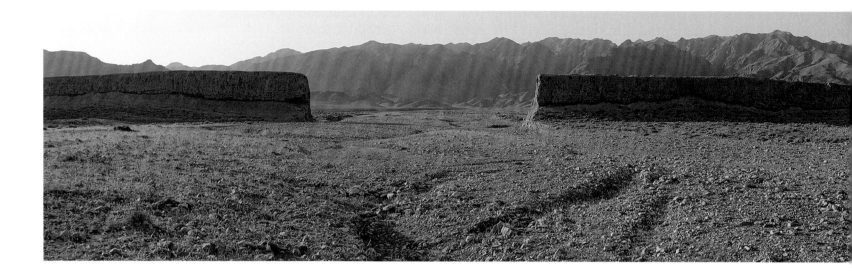

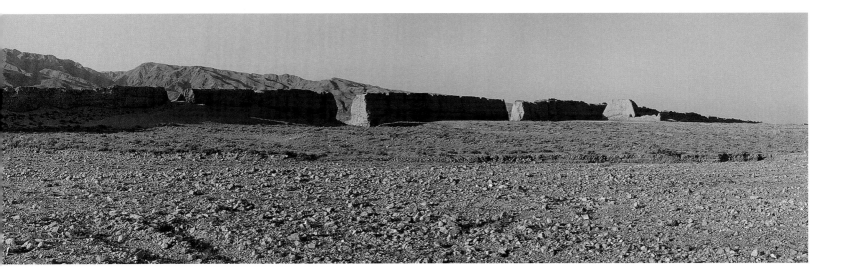

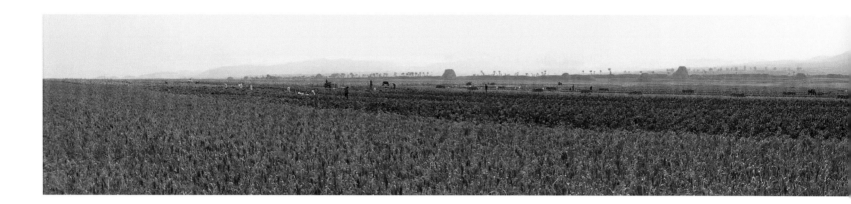

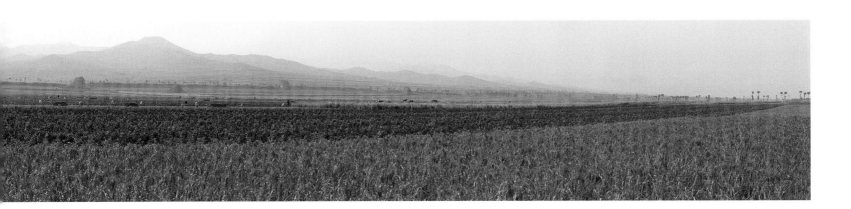

Plate 55 JIANKOU, BEIJING, 2002, inkjet photograph on silk mounted as a scroll [checklist 67]

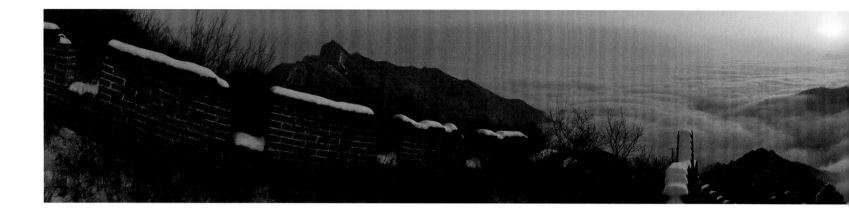

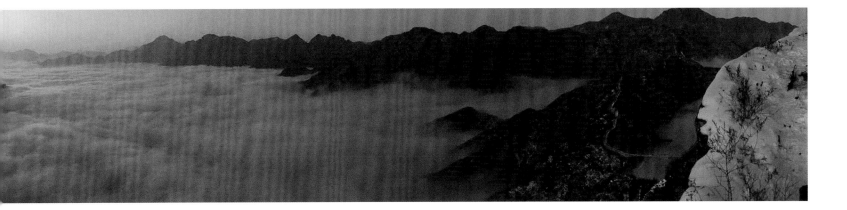

Plate 56 JINSHANLING, HEBEI PROVINCE, 1998, inkjet photograph on silk mounted as a scroll [checklist 69]

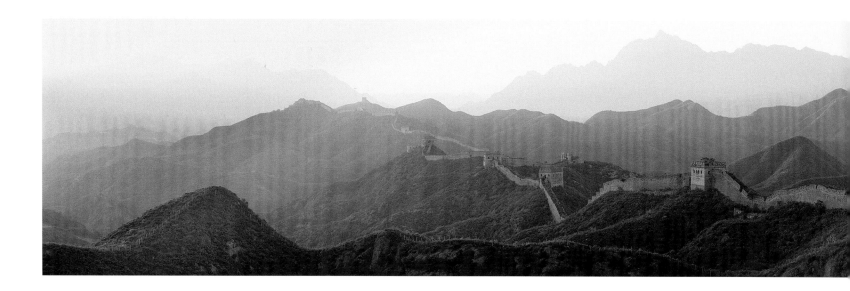

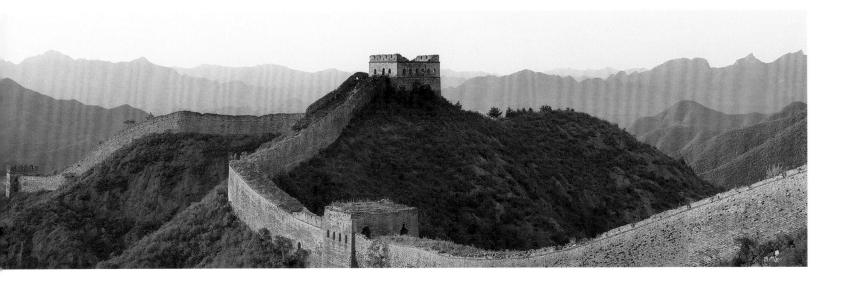

Plate 57 JINSHANLING, HEBEI PROVINCE, 2000, inkjet photograph on silk mounted as a scroll [checklist 70]

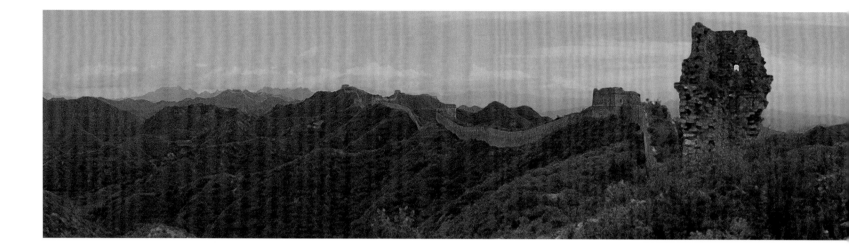

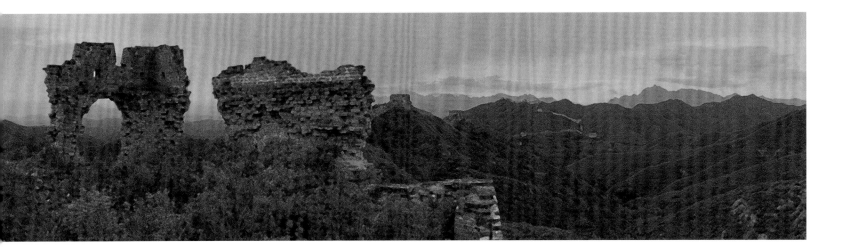

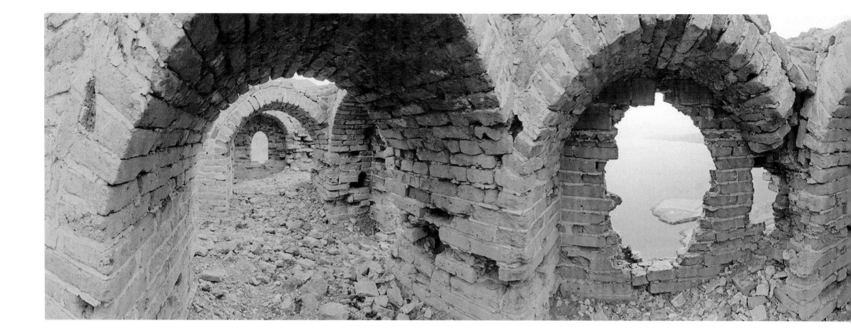

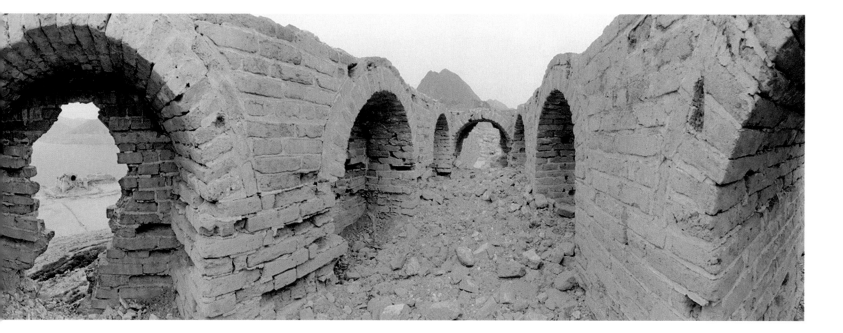

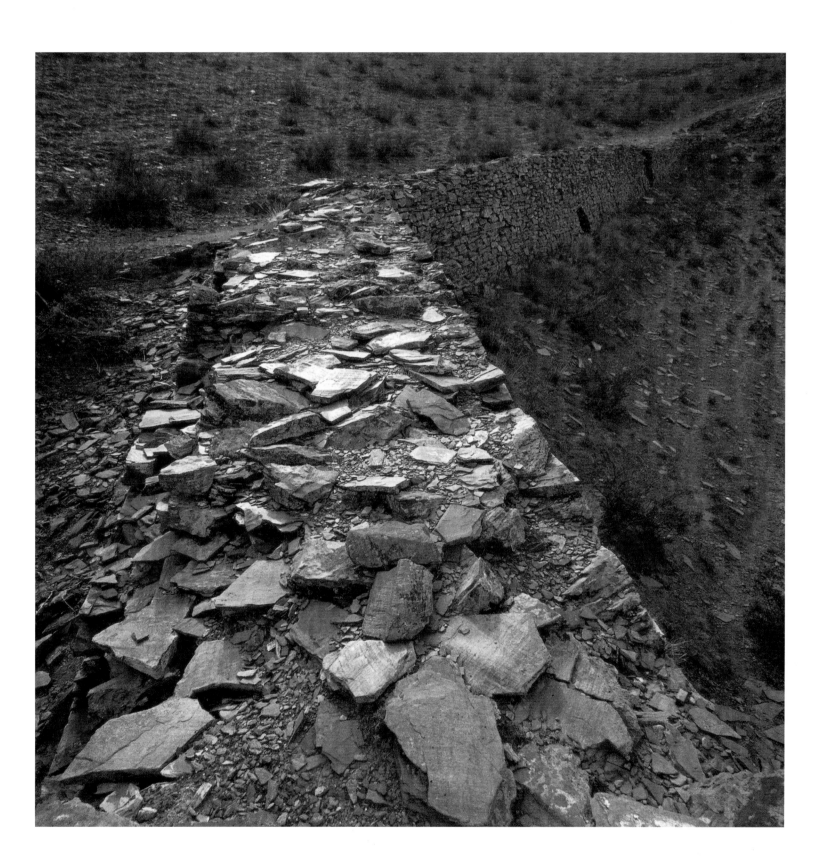

AN INTERVIEW WITH CHEN CHANGFEN

Translated by Edwin Van Bibber-Orr

Chen Changfen Anne Wilkes Tucker

You were born in Hunan. What was your father's profession?

My father was a typical peasant, but he had an open mind. I think that there were two reasons for his openness. The first reason was that, at that time, the British had built two railroads in China, one from Beijing to Guangzhou, and one from Guangzhou to Wuhan. Because our home was next to the railway, my father was influenced by modern Western technology from a young age. He was hardworking and developed many fields for farming on the loose dirt exposed by the railroad construction. He also brought my older sister, older brother, and me along to participate in the work. This type of work shaped my character until I started elementary school, and even then I continued working in the fields. From the time I was young, this work taught me about willpower.

The second reason is that Hunan is an inland province. When my father was young, he was very strong. He once went to Guangdong Province to get salt, which he carried home on his shoulders, traveling several hundred kilometers back to Hunan. The 1930s was a harsh time, but he was success-

ful. Although I never saw my father carrying the salt, when I heard him telling his story, I was moved. This kind of willpower is the most precious gift that he passed down to me. It has allowed me to remain resolute in the living of my life, and has penetrated each stage of my photographic work on the Great Wall.

My greatest luck in life is that I haven't known hardship. I believe that this is a spiritual wealth that my father and ancestors left to me. Additionally, my mother is a very kind person. My mother's surname is Mao, the Mao of Mao Zedong, but I don't think that she has any direct relation to Mao Zedong. She is a typical Chinese mother. These two farmers made the biggest sacrifice to ensure that I could go to school. I remember that in 1993 I went to my parents' gravesite. I knelt there and cried. They gave me so much, but I have given them so little in return.

Fig. 10

WUWEI, GANSU PROVINCE, 1990
Chromogenic photograph

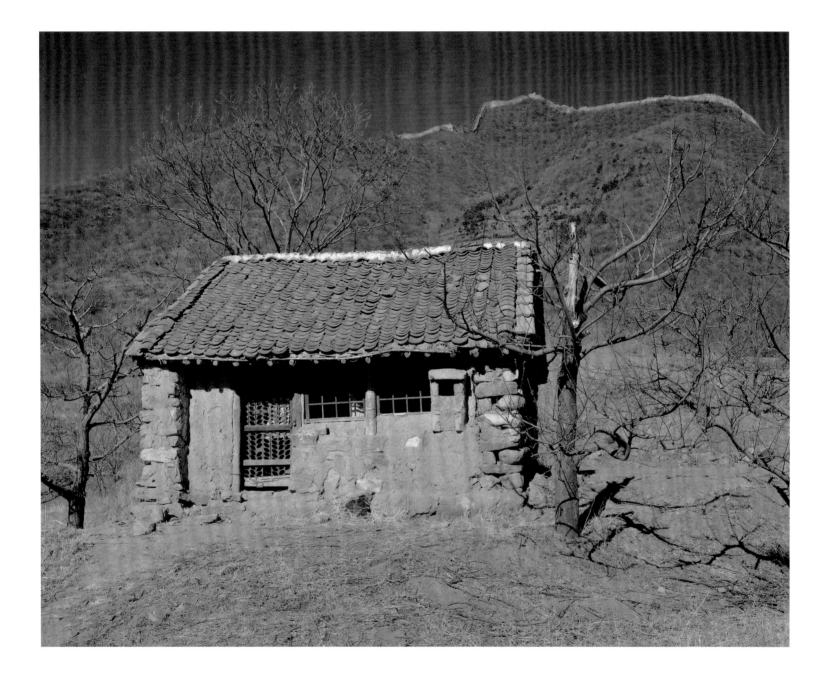

1
Cadre is a translation of a commonly used term that has two meanings: a leader or manager in an organization, or colleagues and office workers.

You give them honor.

But in my heart, I have always wanted to give back to them, which is why I want to do better in my career and be more successful. From a narrow point of view, I can give honor and glory to my ancestors, and from a broader perspective, I can make a contribution to our nation, and in an even broader sense, I'm a member of humanity; I should do what I ought to do as a member of humanity, so I chose the Great Wall.

In terms of the Great Wall, it is not that important to me whether or not the photos I have taken are art, because, in essence, the hands of working people built the Great Wall.

You began to photograph in 1959. Did you study photography with a teacher, or were you self-taught?

I never apprenticed with anyone, and I never had a teacher. At the time, it was just the M3 Nikon camera that a cadre[1] gave me.

Who was the cadre?

It was the leader of my aviation school. At the time I was at No. 4 Aviation School of Civil Aviation Administration of China (CAAC).

Were you studying there?

Yes.

Was that after high school?

That was after junior high school. At the time, the teachers placed a lot of trust in me, as I had had some gift in art from a young age. So from 1959 to 1963, I photographed the spirit of the hardship endured in starting the school.

You just mentioned that, from childhood on, you had some talent for art.

I don't know where this talent came from.

2
Two American medalists, Frank
Wykoff and Jesse Owens, trained,
but did not run, barefoot in the
1936 Olympics in Berlin. Abebe
Bikila from Ethiopia won the
1960 Olympics marathon in Rome
running barefoot.

How did you express this talent? Did you paint, or was it through some other medium?

I think that ever since I was a child, whatever I did, I did in an excellent way. For example, when I was about twelve years old, I participated in a citywide eight-hundred-meter running competition. I didn't wear shoes when I ran—I think America has a sprinter who also runs barefoot.[2] Everybody ran out in front, and when I heard the starting gun, I was behind everyone, but I still finished in first place. Later, when I was in junior high school, I participated in a bicycle race. I had also never participated in such a race before. My gym teacher had a bicycle. I said to him: "Lend me your bicycle. I can do really well." I ended up being No. 1 in the Teens Group in Hunan Province. Maybe it was a gift from God.

Did you paint or play music?

No, neither. When I was a child, I loved to write Chinese calligraphy. My teachers saw my calligraphy and believed there was an artistic element in it.

When the teachers gave you that camera, how did you learn how to use it? Did you read about it? How did you improve your skills? How did you know how to use it? Did you read books?

I gathered, through every possible channel, all the works and material about photography in China. I also got acquainted with a man from a photo studio and asked him to help out with a few simple techniques. The camera in the photo studio was a 10 x 12 in a wooden box, with a leather gun and speeds of one-fifth second, one-eighth second, and one-tenth second. I used this camera to take graduation group photos of pilots for two training sessions of the aviation school. Now those pilots have all retired. I feel honored for having taken the graduation photos of those pilots who were trained during China's most difficult times.

A key reason that propelled me to take up a career in photography is that when I made an image appear on a piece of white paper in the developing chemicals, I felt surprised and excited. From that time forward, my destiny and career were determined.

3
The Great Leap Forward (1958–62) was a disastrous plan by Mao Zedong to transform China from a nation based on an agrarian economy into a modern industrialized society.

Did you study how to work in the studio or darkroom?

I never worked in their darkroom. I only came and went, asking for some help with the simplest things. Everything I knew I learned through practice.

At the time, in the books that you read, were there any works from other photographers that you respected and appreciated?

Yes. In the 1950s, China had many works of art that reflected the Great Leap Forward[3] and the political situation at the time. Looking at them now with a modern perspective, these works are fanatical, and they can be categorized as zealous and absurd. For example, one photograph was of a rice field covered in numerous paddies, demonstrating that one-sixth of an acre could produce fifty thousand kilograms of rice.

Where did you go after aviation school?

In 1963, because of the terrible economic situation in China, the aviation school was unfortunately disbanded. The teachers at the school told me I had two choices. One was to go to Hangzhou, to a sanatorium run by the Civil Aviation Administration of China (CAAC), and be a member of the aviation club there. I was given this opportunity because I had experimented with filmmaking before and had been exposed to moving images. The other choice was to go to Beijing.

When were you exposed to moving images?

In 1959, at the same time as photography. So the other choice was to go to CAAC in Beijing, but I didn't know what position I would have. I chose Beijing without hesitation. In terms of living conditions, Hangzhou probably would have been better, but thinking of career prospects, I chose Beijing.

Did you work at CAAC for a long time?

I have been at CAAC ever since. I'm the chairman of the CAAC Photography Association.

You said that the first time you saw the Great Wall was in 1960. Had you learned of the Wall in schoolbooks before then?

Some of my elementary schoolbooks mentioned the Great Wall. In mentioning the Great Wall, the books would mention two figures: one was a great leader—Qin Shi Huang. On one hand, the books confirmed the emperor's achievements. For example, after unifying China, he formulated many different systems, including farming, weights and measures, and roads. I remember that when I was young we all memorized the sentence "Qin Shi Huang unified China." On the other hand, there is another definition of Qin Shi Huang; that he was a tyrant who initiated the construction of the Great Wall, which led to the deaths of hundreds of thousands of people. Among the countless people who suffered from the construction of the Great Wall, there was a person named Meng Jiangnu who acted as their representative [see p. 8]. She was the wife of one of the laborers who built the Great Wall. Her husband was dispatched to build the Wall, and husband and wife were unable to see each other for many years. Every day, Meng Jiangnu felt distressed for the great hardship her husband was suffering during the construction of the Great Wall. Eventually her husband died on the Great Wall, and Meng Jiangnu cried for a very long time. Finally she collapsed the Great Wall with her crying.

> Qin Shi Huang conceived the Wall, and Meng Jiangnu suffered a tragic fate
> because of it—in your opinion, are these two key figures?

Yes.

> Your first photograph of the Wall was taken in 1965 for Swissair?

Actually, in 1962 and 1964, I climbed the Great Wall, but I was only there taking some pictures as souvenirs for friends. About 1965, the Swissair Publishing House wanted to send photographers to China to take aerial photographs. At that time, China was still a closed society, so it was impossible for foreigners to do this work. The Swissair Publishing House wrote three letters to Zhou Enlai, then premier of China. Premier Zhou Enlai saw its relevance to international relations, but since it was not possible for foreign photographers to fly over China, the largest Chinese news agency, Xinhua News Agency, was charged with the responsibility of sending reporters to help the Swissair Publishing House complete the project. The team of photographers included staff from the Xinhua News Agency and the CAAC. I was charged

4
The Cultural Revolution began in 1966. Mao himself officially declared the Cultural Revolution to have ended in 1969, but the ending date most widely used is the arrest of the Gang of Four in 1976.

by the CAAC with the organization of the event, so I had the opportunity to take photographs from an airplane with the photojournalists.

Other than Beijing's Great Wall, we also went to other famous places, including the Yangtze Bridge and Wuhan Steel Company in Wuhan, the Huangpu River in Shanghai, and a very nice area with modern architecture in Shanghai—Minhang. After inspecting all of the images, we sent them to the Swissair Publishing House, but I have no idea what happened. At the time, I used the Kodak color reversal film, and now I have only one photo left.

Right after that, the Cultural Revolution began?

Yes.

Were you still able to photograph during the Cultural Revolution?

The Cultural Revolution [1966–76] was a unique time for China.[4] People were in a state of mania. I photographed many of the people who were facing persecution, including those within the banking system and those in society.

During the Cultural Revolution, did you continue to photograph the Great Wall?

During the Cultural Revolution, political actions were carried out every day, so it was impossible to shoot the Wall. In that period, many parts of the Great Wall were demolished under the notion that the Wall was a feudal and backward thing. Peasants around the Great Wall area took bricks from the Wall to build their own houses, make beds, and even build pigsties and bathrooms. So I think that the Cultural Revolution in China was in actuality a paring away of Chinese culture. One can say that it was a revolution, but it didn't have to be a *cultural* revolution, because it brought too much destruction along with it. In another sense, it did toughen a generation of young people. Workers were transferred to work at grassroots levels, and young intellectuals were sent into the mountains and countryside; they all made significant sacrifices while at the same time strengthening their wills. Afterward many of the people who were sent to the countryside played an important role in opening China to the West.

After the Cultural Revolution, you decided to photograph the Great Wall again?

I resumed photographing in 1973. At the time, CAAC planes flew around the Great Wall to spray pesticide, and I took the opportunity to photograph the Wall; this was my second opportunity to photograph it from an airplane. This time I felt even more strongly the greatness of the Great Wall. When I was photographing the Wall for the first time with the Xinhua News Agency, I was providing service for others. But in 1973, it was my own initiative.

In 1978, I had another chance, and I borrowed a plane from the CAAC to photograph some of the most beautiful places in China, including Huangshan and Guilin, but first and foremost was the Great Wall. This time, my work was successful, but those photographs were not published until 1987. When they were published, I had made some changes to their original flavor. Originally they were realistic, while later on they became expressive.

When did you begin going to photograph the Great Wall on a more frequent basis?

In 1981, after I helped establish the *China Civil Aviation Magazine*. At that time, I had even more opportunities to take photographs of the Wall. In those days, China only had one day of rest during the week. Almost every weekend I would go to climb the Great Wall, sometimes with my wife, sometimes with our son, Chen Peng, and sometimes with the whole family. At the time, Chen Peng was only seven or eight years old.

One of the places we went to was Jinshanling, and at the time none of the roads leading to the Great Wall was paved. We went by paddle tractor and felt as if all of our guts would fall out. Sometimes we would take a train to the Gubeikou section of the Wall, bringing bicycles along with us. When we got off the train, we would bike to the Wall.

Were you using 35mm color film, or were you using negatives?

Yes, 35mm and both slide and negatives, but at the time the quantity of color film was extremely limited. It had to be special ordered. Jinshanling had yet to be restored. I think that there were no more than

5
The Kuomintang Party, led by
General Chiang Kai-shek, was in
a civil war with the Chinese
Communist Party, led by Mao
Zedong, from 1927 until the
Communists gained control of
the Chinese mainland in 1949,
excluding, of course, the years of
Japanese occupation during
World War II.

ten photographers able to photograph Jinshanling before it was restored, and I can proudly say that I am one of them.

When was the first time you went west to photograph the Wall?

I think it was in 1988 when I went with the goal of photographing the Great Wall. I had been west many times before, but never to photograph the Great Wall. There was another reason that propelled me to go to the northwest to photograph the Wall. At that time, Chinese pop music had just started to become popular, and there was a very famous singer named Tian Zhen, who at the time sang a very popular song called "Northwest Wind" that made me want to go to the northwest. I had been to the northwest many times before, and in 1969 I spent more than a year there at a place called May 7 Cadre School, where cadres were sent to do grassroots work. I worked and labored at a reform-through-labor farm for more than one year. That strengthened my will.

When you were sent to work at the farm, was it in order to take pictures, or was it for reform?

Both. I also took photographs there. There are two things that happened there that are worth recalling. One was that I saw a mirage over the Huang He [Yellow River], and the other was that I swam across the Yellow River where its width was three thousand meters. After I reached the other side of the Yellow River, I bought a semiconductor radio, wrapped it in a plastic bag together with my clothes, held the bag up with one hand, and swam back across the river using only one arm. But when I tried to climb the bank, I couldn't, because the bank was so muddy. I ended up a thousand meters downstream. At that time, I was twenty-two years old. I was told that I was the fourth person ever to swim across the Yellow River there. The three before me were all conscripts captured by the Kuomintang,[5] and they had jumped into the Yellow River to escape.

What was the mirage that you just mentioned?

The mirage appeared in the form of buildings on the winter ice on the surface of the Yellow River.

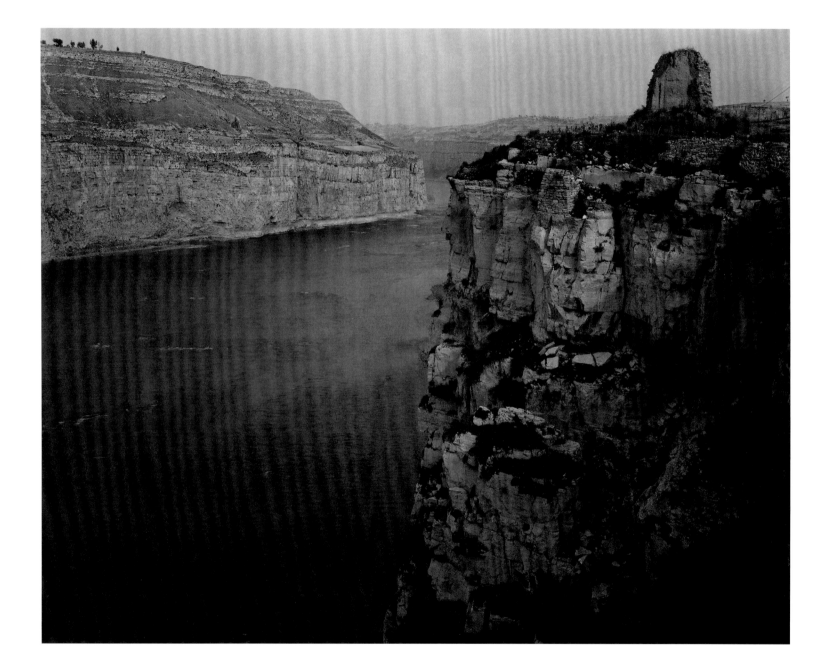

6

Chen Changfen, *The Great Wall:
A Cultural Walkway* (Tokyo:
Kawaide Shobo, 1990).

7

That book will be released in 2007.

8

The Chinese word *Zhen*, which is
a Daoist term, has many English
translations, including *real, real-
ized, realization, true, perfected,*
and *perfection*.

9

See discussion of *qi* on p. 25.

**When did you first read Heinrich Schliemann, and what sort of effect did
it have on you?**

The first time was in 1988. It amazed me that a foreigner could describe the Great Wall in such detail,
so movingly and with such admiration. I couldn't understand it. As a Chinese person, I felt ashamed,
and I felt ashamed for many Chinese people—they couldn't comprehend the Great Wall or understand
it. Why did people condemn the Great Wall? Schliemann praised the Great Wall, praised it in a big
way. He condemned the then-ruling Qing government, which was incompetent and had turned a great
nation into a dishonorable one. How could there be nobody in China advocating and praising such a
man-made miracle as the Great Wall? I think the two situations are different. Schliemann had already
solved his basic needs, and he was a wealthy person compared with the Chinese people. At that time,
Chinese people were poor and starving, and their basic needs were not met. I think culture can be devel-
oped only when the basic necessities of life are met. If I were a beggar, I would not be thinking deeply
about culture. Instead, I would be worried about lunch and dinner.

So, as a Chinese photographer, I think I have the obligation and the possibility to make a kind of
expression to the people of the world with the Great Wall. That's why I hope that I can make five books
of photographs of the Wall. I believe I can definitely find my art in the Great Wall.

Why five?

The first book was published in Japan [in 1990].[6] The second book, *The Great Wall Epic*, will be the color
images printed on rice paper in a limited edition of fifty books, and I hope to publish it this year or early
next year.[7] The third [is this] book. The fourth will be on the 8 x 10 inch black-and-white work, and the
fifth will be on the panoramas. I would also like to add another book on the people along the Wall.

As I said before, these books will each have different content, style, and thought, including traditional
and avant-garde, as well as the highest form of Chinese philosophy, Zhen.[8] I think in the Great Wall
we can find a sort of Zhen *qi* field.[9] This idea of *qi* is very difficult for writers to express in words, for
painters to express with their brushes, or for photographers to express with their photography, but I
believe musicians can express it, so music has the richest Zhen in it. If you want to have a small grasp
of Zhen, there is just one sentence: Zhen is something that cannot be expressed with words.

10
See p. 34.

When did you start to relate your photographs of the Great Wall to these complex philosophical ideas, like Zhen, Daoism, Confucianism, and Buddhism?

It was after 1987, because then I began to feel that if I used the method of realism to express my feelings for the Great Wall…

Realism?

The realistic method.

You wanted to use the realistic method of expression?

I couldn't keep using the realistic approach as a means of expression. After finishing my first books, I made a summary of my photographic experience. The first book, published in Japan, is a realistic display of the Great Wall. From a Chinese Zhen perspective, it was "look at a mountain and you see the mountain"; or "look at the Great Wall and you see the Great Wall."[10] It's telling people what the Great Wall looks like. Regrettably, in this book I used a couple of fish-eye lenses, which I of course don't like now. After this book was finished, I started thinking how to express the Great Wall in my second book. If I used the same thought and same style to photograph the Great Wall, I felt I couldn't continue, as I would be duplicating my previous work, because my goal wasn't to photograph every part of the Great Wall.

So, in my second book I plan to give priority to pictures taken with the Hasselblad camera, so as to express the second meaning of Zhen, that is to say: "look at the mountain and see that it is not a mountain," or "look at the Great Wall and see that it is not the Great Wall." I believe I was doing the second phase from a higher perspective than the first book. Although it's still realistically documenting the Wall, I made more use of changes in nature, and I blended the seasonal changes, my own feelings, and other artistic languages into the pictures.

Such as?

Such as the languages of music, painting, and sculpture, and so forth. I spent the most time and effort on the second book.

We talked before about how many of your photographs contain symbolism —like using frozen grass to express remembrance for those who gave their lives for the Wall. Did this kind of thinking begin at the same time?

Yes, I think it did. I saw a photograph called *Wordless Monument* of a monument with no words written on it. Although there is significant historical documentation of the Great Wall, including records of officials involved in the Wall's construction, there are no records of the laborers who built the Wall. I think this is the unfairness of society. So I thought of doing a small thing. When the Capital Airport planned to build a new terminal for the 2008 Olympics, I thought about taking pictures of each and every worker on that construction site, and making a huge book. It could consist of thousands of peasants.

Did you do it?

No. Often I think a lot and do little.

Can you talk about your view of the people who are living now on both sides of the Wall?

I don't think their life is much different in principle from that of people in other parts of China. Parts of the Wall were demolished by many of the people living on both sides of it. Some people living along the Wall have deified the Great Wall, and they have a kind of awe toward some parts of the Wall that are precipitous and dangerously steep, fearing there might be ghosts and spirits there.

You talked about how some of the local farmers see the Wall as a difficult part of their life, like the farmer who has to climb over the Wall to go visit his sister. Does the Great Wall actually still have any practicality?

In this sense, the Great Wall is no longer a wall for defense.

The Great Wall is part of the lives of people who live beside it. They get up, they look at it, see it ten times a day, twenty times a day. It must affect them on some level, or do they just take it for granted?

Once I interviewed a farmer named Wang Jizhong. I asked him when he came to live beside the Great Wall, and he said his family has been here for hundreds of years, for many generations. As I talked with him, I felt he had a sense of pride. I think this pride comes from a new meaning that we have attached to the Great Wall as a cultural legacy of the world. If it wasn't for this, I don't think a farmer who tills fields every day would have many special feelings toward the Wall, because over the past few hundreds of years, or even one or two thousand years, it was primarily literary people who paid some attention to the Wall. Schliemann praised it because he was an archaeologist; Marco Polo praised it because he was a traveler and a scholar.[11] They can't be mentioned in the same breath as peasants. Of course, if someone comes to demolish the Wall, or blow it up, the people living beside it will pay special attention to it and try to stop it—they would certainly try to put a stop to this kind of behavior. But if an outsider takes away a brick or a tile, they wouldn't interfere with it much. But I feel that protecting the Great Wall is our responsibility too.

> You have said that the Great Wall and the natural environment have melded into each other with the passage of time. You also talked about the idea of personifying the Great Wall. Could you please talk again about the relationship between the Great Wall and the natural environment, and the relationship between the people living alongside the Great Wall?

This is a kind of interdependent relationship that exists not just between people and the Great Wall. If I were living beside a river I would form an interdependent relationship with the river. In such a relationship both sides benefit; this is the basis of relationships. Otherwise people would challenge and reform the environment.

> But in talking about interdependent relationships, what aspect were you referring to? Were you talking about the Great Wall and the natural environment, or something else?

In recent years, because of growing international interest in the Great Wall, and because of the interest of the Chinese government and the fact that it has come to be seen as a cultural legacy, many peasants

11
Actually Marco Polo did not mention the Wall, but a Chinese-American joint television production *Marco Polo*, which aired in 1982, stated that he did. See Arthur Waldron, *The Great Wall of China: From History to Myth* (Cambridge: Cambridge University Press, 1990), 21–22.

Plate 62 HUANGHUACHENG, BEIJING, 1995, inkjet photograph on rice paper [checklist 8]

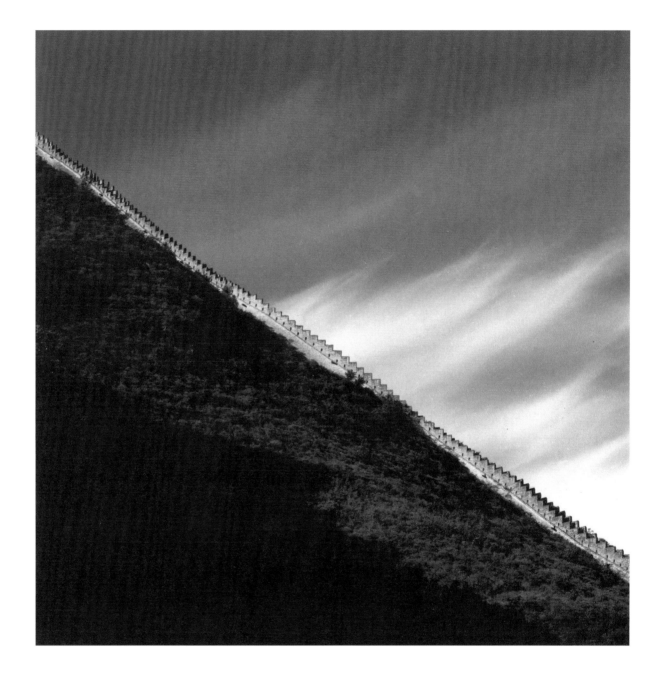

have benefited from the Wall. For example, in the Jiankou section of the Wall, every peasant can get 500 RMB [US$62] per year as a subsidy for protecting the surrounding forest, a sort of compensation. As the peasants get economic benefits from the Wall, they feel more responsibility for protecting the Wall.

But what does protecting the forest have to do with protecting the Great Wall?

Because the Great Wall is not isolated—many parts of the Wall are in the middle of a forest. In case of a forest fire, it will cause substantial damage to the Wall. Thus, you can see the relationship between environmental awareness and its benefits.

Did you consciously go to photograph the different physical structures [tamped mud, mud and willow branches, and stone] of the Wall?

Yes. If photography is taken as formative art, the shape of a structure is important.

You also photographed the variance of weather and the seasons?

As a structure, if the Great Wall was not in harmony with the environment, it might become rigid and lifeless. If it lacked the influence of the surrounding environment, it would appear too isolated. It's just like building a villa. If a villa were built without considering the surrounding environment, without planning its gardens, then we would say that it was not a complete villa. But it's important to know what's primary and what's secondary. The primary is very important. Here, the Great Wall is primary.

And the weather is secondary?

If we are talking about visual effects, I don't think we can say it that simply. Sometimes the weather can be the main focus, but in most of my pictures of the Great Wall, the climate is the secondary factor.

Your knowledge of the Wall and its regions has given you some advantages. For example, you know that if you go to a particular section after a rainstorm, you might get a rainbow. You have a special understanding of the climate.

Plate 63 HUAIROU ZHUANGHU, BEIJING, 1996, inkjet photograph on rice paper [checklist 9]

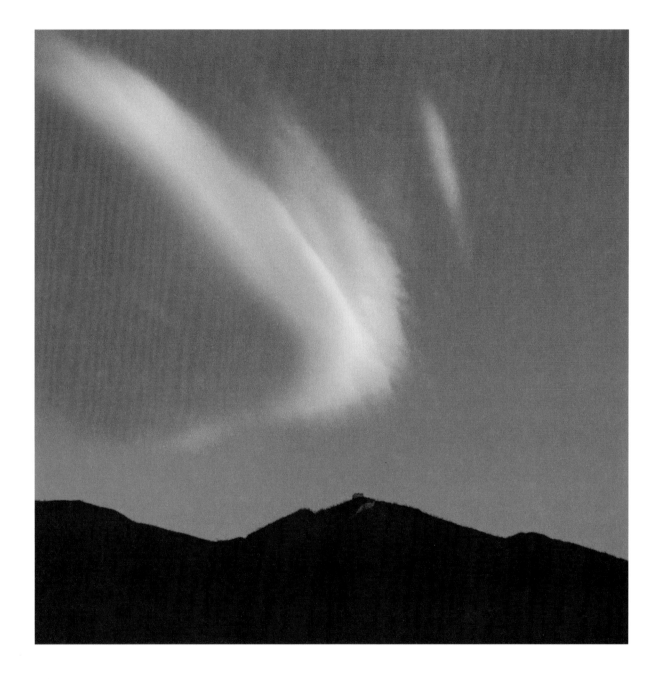

Take, for instance, the Jiankou section of the Great Wall, which has very peculiar topographical characteristics. It rests on a mountain that rose up abruptly out of the North China Plain. The variation in altitudes is at least six hundred meters, thus forming a counterflow of airstreams, as well as a variance in temperature and humidity between the top and the bottom. These things are all very relevant to photography. There are also the changes in vegetation. For example, if I know that the leaves are red at twelve hundred meters, I can forecast that around three hundred meters the leaves will be red in a week. Similarly, if the leaves on the summit have started to fall, the leaves at the bottom will still be fine. But sometimes the weather is unusual. For example, if there is a huge frost one night, followed by a big wind the next day, then all of the leaves will fall. Because landscape photography has important implications in the photographing of the Great Wall, a landscape photographer must have a good understanding of astronomy, geography, and the climate.

Did you consciously decide that you wanted to photograph Jiankou in each season, or was it part of the process of going there so often?
Capturing the colors of all the seasons is important.

You've also photographed in diverse climates.
In the winter at Jiankou, it can be 25 degrees Celsius below zero [minus 13 degrees Fahrenheit]. In the west, June temperatures in the desert are sometimes dangerously hot.

In those temperatures, cameras don't function well.
I usually use mechanical cameras, not electronic. They function well. As for myself, if it is extremely hot, I have to splash water on myself while I work. If it is extremely cold, I sometimes use a mini handheld oven.

Do you use the lunar calendar?
Yes, I use it a lot. For example, when I photograph the moon, I know very well when it will be the first-quarter moon, last-quarter moon, full moon, or half-moon; I know where the moon will come out in a certain season, and when and where the sun will come out.

Plate 64 YOULOULING, JIANKOU, BEIJING, 2004, gelatin silver photograph [checklist 50]

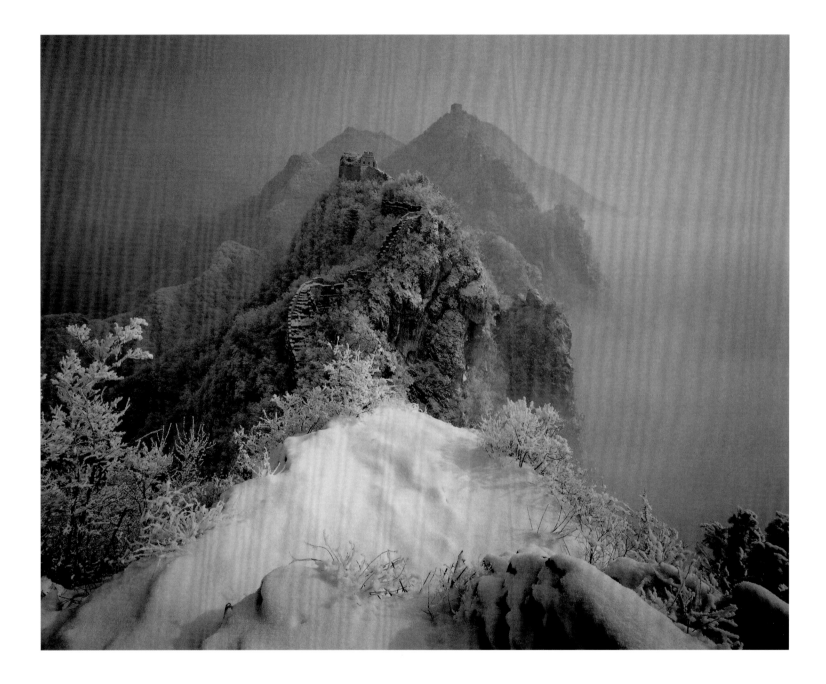

Have you ever…looked at the Wall and felt that if the moon were out it would be especially beautiful? Did you know where you would be able to see the moon?

I knew where the moon would come out, and I photographed it often. I have to think about things like the time the sun sets, the height of the moon's rise in the sky, and the sky's visibility, and so on, but I have never advocated the idea of adding a moon to a photograph.

Was the jet trail in two pictures an accident? Did you know that a plane would come?

I didn't think about having a jet trail in the beginning, but when I saw the plane coming, of course I had to capture it. As a photographer, you come across many things you can't foresee, but when you get into those special situations, you have to react very quickly—including the anticipation of shutter speed. For example, if it were set too slow, the plane would be blurry; if the aperture were too big, then there would not be enough depth of field.

There's another picture in which a plane has just crossed the sky. The contrast between the modernity of the jet and the ancientness of the Wall— is that something you were seeking?

Yes. When something historical collides with something modern, it can deepen humanity's thinking. In 2002, when I gave a lecture in the United States, I compared the Wall to a network. The Great Wall's function as a network is very clear: it had the basic function of passing on information, such as the signal towers—that is the clearest example. Secondly, there is a wide road on top of parts of the Ming wall, which also has the function of a network. Looking at this from another angle, when we lift our heads to look at the sky, airplanes themselves have implications as networks. Interestingly, a very long section of the Great Wall coincides with flight paths, and it also coincides with the Silk Road.

Why?

It's decided by geographical positions, and maybe even the pilgrimage of the Tang dynasty monk Xuan

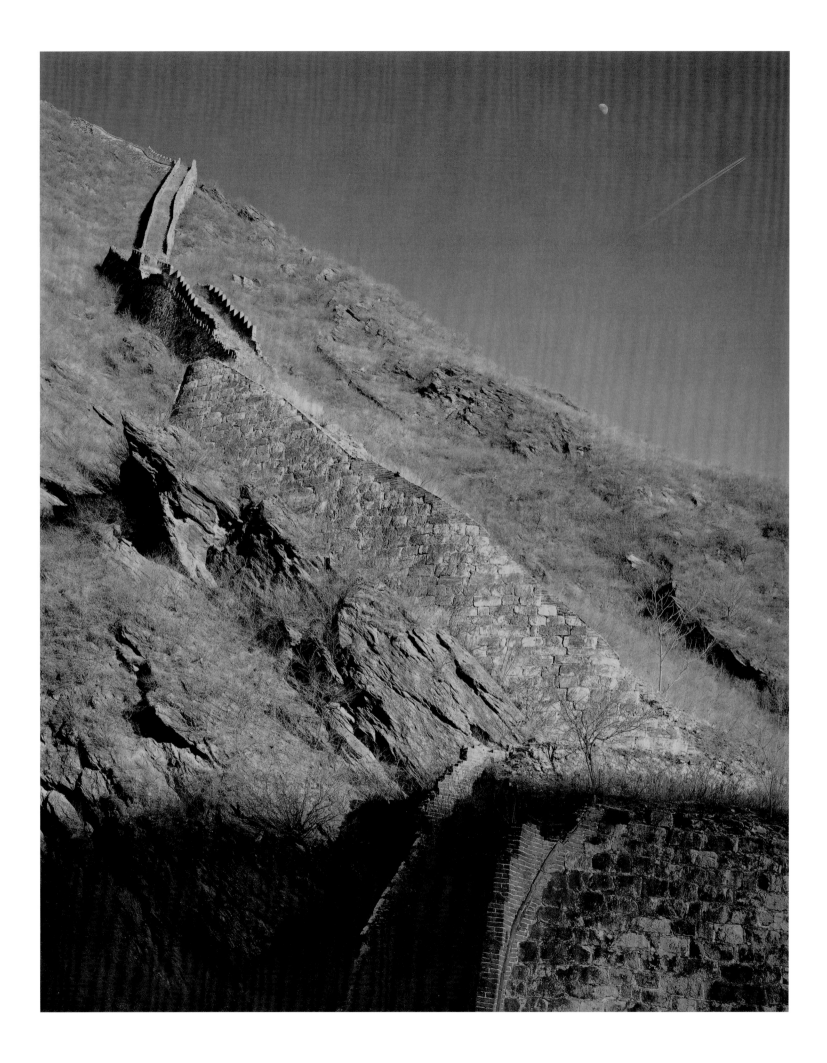

Zang (602–644/664), who went to India for Buddhist scriptures—they are also connected to the Great Wall in a significant way.[12] Our ancestors were like us regarding the concept of networks. Maybe this has nothing to do with photography and the art of photography, but this kind of thinking broadens our minds, after which we can use some of the conclusions of our new thinking in our everyday work and life.

12
Xuan Zang came from a scholarly family and became famous for his seventeen-year trip to India, during which he studied with many Buddhist masters. When he returned to China he brought with him some 657 Sanskrit texts.

A great picture, whether it's a painting or a photograph, is something that can engender thought in a diverse range of people with a diverse range of perspectives. For example, there might be a difference in what geologists think when they look at your photographs and what others think.

That's why I especially advocate multidimensional thinking in photography.

What separates your work from that of other photographers is that other works exist mainly on one level: the Wall and the moon, the Wall and a rainbow—but your work is multilayered. When you exchanged the 2¼ camera for an 8 x 10 camera, it was not only a technical change, but a philosophical change as well.

Well said. My thinking is multidimensional. My family members often complain that I think too much in detail; I say that their minds are too simple. I think that many people easily misunderstand photography as simple work. I don't mean that I have to change this concept, but if I can do something filled with more thought, it isn't a bad thing. So I want to inject more information into my pictures. I've received many comments from many contemporary Chinese artists.

Who are they?

Many, including Jin Shangyi, Yuan Yunpu, Yang Yunsheng, and a lot of critics. In 1988 they held a symposium for me and invited many Chinese artists. In addition, there is Sun Meilan, whose understanding of my Great Wall photography is very important. She is a retired professor of history at the China Central Academy of Arts. Her understanding of the Great Wall is very important to me. She recommended the article that Schliemann wrote in 1860. The article was translated into Chinese by a very

famous literary scholar, Zong Bohua, and was published in 1962. Schliemann came to China in 1860, and not until about a hundred years later did Zong Bohua translate his essay. You can see how under-developed China's information system has been.

Why did you switch from a 35mm to a Hasselblad camera, and then, recently, back to occasionally using 35mm again?

The 35mm is very light and convenient. It's indispensable for photographing news and documentaries. I have three Nikons. They are very easy to use, and the quality is good. [The 35mm] was a main contributor in photographing for my first book; but when I began to photograph for my second book, I felt the picture quality of the photos taken with 35mm couldn't satisfy my needs. What I mean is a kind of personal satisfaction instead of a technical one. I simply always felt that larger negatives were better than small ones in their resolution and in the expressive force and texture that can be achieved. When I was making prints, I realized that if a negative from 120 film is used to make a print exceeding one meter, its texture is affected significantly. So, after 1995, I thought of using an 8 x 10 inch negative camera. At that time in China you couldn't find an 8 x 10. In 1996, I saw a second-hand camera and bought it without hesitation. It was expensive, costing me more than 30,000 RMB [US$3,750], and the lens was a Japanese Fujinon, so I quickly bought a new German Rodenstock to replace it.

Not very long after I bought the camera and took photographs, I was quickly able to publish them. More recently I have published other photographs in *China Photography* magazine, and I wrote an article titled "Experiencing 8 x 10." After it was published, the article created a reaction in China. Many photographers, either professionals or amateurs, actively went to buy 8 x 10 and 4 x 5 cameras to take black-and-white photographs. My friends immediately set up a Large Picture–Format Association [Dahuafu Sheying Xuehui] and selected me to be its chairman.

As we just mentioned, your switch to the 8 x 10 was not only a technical change but a philosophical change as well.

That is a good comment. Technically speaking, although the 8 x 10 lags behind in world photography trends, it has many excellent functions that cannot be replaced by modern smaller cameras. For me as

a photographer, the language of photography and the feeling of early photographic techniques are extremely important. In this sense, Chinese photographers, compared with their American counterparts, lack experience with early photographic techniques. It's because of this that some foreign photographers and photography magazines believe that China does not have photographers in a real sense. I think there's some truth in these kinds of comments; therefore, I want to mobilize friends across the country to…bridge the gap. In my lectures and articles I refer to this as "making up a missed lesson." In countries where photography is very advanced, people cannot understand this. I think for a Chinese photographer, especially for me, it is a kind of suffering.

Why do we lack this experience? It is because when the rest of the world was at the height of photographic development, China was in a state of revolution, and the development of photography as an industry was adversely affected. At that time, we didn't have big formats, such as 14 inches, 16 inches, 20 inches, and 24 inches. I wanted to fill that gap. Eventually, my friends created a 20 x 24 inch–negative camera for me.

I would like to form a comprehensive and complete series of Chinese photographs that consists of various formats, ranging from the smallest to the largest. I would also like to make a movie at Jiankou. As a photographer that people have honored, I hope I can have a dialogue and communication on an equal footing with other successful photographers in the world.

In the article I wrote after I first took photographs with an 8 x 10, I said that I wanted to take ten photographs of the Great Wall within two or three years, but as soon as I started, I couldn't stop. It was no longer an issue of ten photographs. I simply got addicted. I think the 8 x 10 has a truly superb expressive force.

I discovered that the black-and-white photos taken with an 8 x 10 were completely in harmony with the structure of the Great Wall. The Great Wall itself is composed of black and white and gray. With the combination of various photographic apparatuses, such as filter strips and lenses, you can display the Wall wonderfully. For example, the brickwork joints of the Wall are white, the bricks are gray, and the shadows of gaps between bricks are almost black. If we use color film and the morning and evening light to photograph the Wall, we may change its original appearance. Thus, I feel I've found a way to photograph the Great Wall as it is—but this is different from the first book, and this seems to have raised

the bar, because there is a lot of abstract thought in it. I always believed that black-and-white photography itself is abstract, as it takes out many colors of nature and life, and abstracts the object into just black and white.

> In a black-and-white photograph, the Great Wall is more prominent than nature; whereas in a color photograph, nature seems to be stronger than the Wall, because nature is more brightly colored.

Because the colors of nature can change the essence of the Great Wall. So it is still the philosophical concept in the poem that I was just talking about—that is, "looking at the mountain and seeing that it is not the mountain" [see p. 34]. This theory may not be completely in accordance with Chinese Zhen, but there exists an essential coincidence between that concept and my work.

I can find a kind of understanding only in my work, my life, and my pursuit of art. In the many books I've read about Zhen, I haven't found any specific explanation about the three meanings in the poem. Later I realized that everybody's understanding of Zhen is different, and I think this too is Zhen. To me, the first meaning of the poem is that you look at a mountain, and it's a mountain; or you look at the Great Wall, and it's the Great Wall. This is a person's most primitive perception of things. For example, the photographer Judit Stowe told me that in Hungary there's a very beautiful bridge, or a very beautiful church. I haven't seen them, but I just have to go. After I go there, I'll quickly feel, "Oh, this is the bridge or the church Judit told me about." This way, I can completely reconcile what Judit has told me with what I see before my eyes.

Similarly, before I went to Mount Everest, some of my friends learned about it through television and photographs and told me how great, how tall, and how white it was. Before I went, my impression of it was based on second-hand information. Then I went there and saw it, and what people had told me coincided with what I was seeing before me. This is the most primitive kind of coincidence, the simplest, and the most honest. This is the first layer of Zhen meaning. After I understood Mount Everest, after I stored its original image in my brain, I would try to think of ways to change its image through different methods of thinking and expression. The image of Mount Everest I saw for the first time was the most typical and representative, but I tried to overturn this image. I wanted to find another

perspective and understand it with my own thinking. I would realize that Mount Everest is not only the image that others described; rather, there is more meaning to it. Such an understanding may contain some subjective awareness—romantic, selfish, and even impulsive awareness. This is the second layer of Zhen meaning.

After experiencing the first and second layers of meaning I wanted to go home, quietly reflect, and perform the most essential analysis. I wanted to find its most accurate and intrinsic meaning and especially wanted to analyze its essence, so as to grasp a few of the most essential things. At the same time, from an artistic point of view, I can express the mountain with abstract thinking. We can make Mount Everest a sacred mountain. In my eyes, Everest is not just a mountain. Maybe it's a spirit, maybe it's God—it is the spirit of humanity. This is my own understanding of Zhen meaning.

Your works are introspective.

My understanding of Zhen and my understanding of religion might not be exactly the same. This is something that I have come to feel through my involvement in art and photography—maybe this is my Zhen. My Zhen is different from others' Zhen. Everyone's Zhen might be different. This is Chinese philosophy, which contains a spatial way of thinking and is different from the precise scientific methods of the West. I just read an article yesterday, saying that after the year 2010, the world will go through a great change, and that China's Confucian culture might influence the world. The center of Confucian culture is mutual tolerance, amicability, and assistance between people. Confucius had a famous saying: "Isn't it a joy to have a friend visiting from afar?"

So it isn't just Zhen that has influenced your work. Confucian philosophy has influenced you, too?

I have been influenced by both Confucianism and Daoism, but mostly from Daoism because Daoism is more abstract. In Daoism there's a concept called *wu wei*, "nonaction." It means that people shouldn't have too many desires and should not overly pursue their desires, including material life. This may be quite different from the West. Of course, people also need to have pursuits. Without pursuits, there

13
Tacit knowledge is a Daoist
concept.

would be no goals. But if everyone is pursuing things, then various conflicts of interests occur. This is something that people need to think about most in the world today.

Earlier you mentioned pursuing a life of contemplation. Is the switch to 8 x 10 related to a part of this pursuit?

I don't talk about the question of pursuit in my art. Maybe when I was young I talked about pursuit. But in the last ten years, I have stopped talking about pursuit. Because pursuit is not free; it's passive, it's depressive. I advocate freedom—something like a free realm. Once *Traveler* magazine interviewed me and asked me to talk about pursuit. I said, "I don't talk about pursuit. Now I don't pursue anything." I told the reporter many of my ideas, and finally he also agreed with me. When the interview came out in the magazine, it was titled "Chen Changfen Does Not Talk About Pursuit."

But I do indeed find a very special feeling in the 8 x 10 format, a feeling of the language of photography, as well as a kind of physiological feeling linked closely with my body. When I pick up an 8 x 10 camera, I feel it's almost connected to the structure of my body. It has a kind of spirit, and I can even have a dialogue with it. So although the machine is heavy, I don't feel it. Maybe this is an extraordinary, tacit understanding and coincidence.[13]

When you are taking photographs, do you ever hear music in your head?

In photography, the first thing to pay attention to is rhythm, including the rhythm of setting up your instrument and of inserting film, and, of course, the best music is that of the shutter—what its sound is like in one second, in an eighth of a second, in one two hundred-fiftieth of a second, and in one five-hundredth of a second. It gives me a very simple feeling of the space between moments. Also, in gathering up your instrument, and in changing film, there is a musical feeling. When the wind is blowing, the wind comes from beside the instrument, blowing through the tripod, giving people a special musical feeling.

When you are in the mountains using your 8 x 10, is wind a problem?

Yes, this is a common headache with people using big cameras. You can only take pictures when the wind

stops, or when you can estimate that the shutter speed is faster than wind. But it's almost impossible for wind to become completely still, so you have to seize the moment between two gusts of wind. On the other hand, sometimes I'd like to have wind so I could photograph the sensation of movement, but then there is no wind. In these kinds of situations I take the black slide from the 8 x 10 film and use it to simulate the action of a fan. In reality it's useless, but I use it to create a personal effect for me. Similarly, if the wind blows all the time in a place, and the leaves are always moving, I'll make gestures to stop the wind. I'm actually forcing myself to constrain myself, to not be anxious, in order to achieve a calm state of mind. This is something that I learned from my parents and neighbors as a child, a way of stopping the wind, like a kind of witchcraft—this is closely related to the Chu culture of my homeland. I think that these methods can increase the quality and training of photographers, who strive to attain harmony with nature. I don't think that I am being idealistic; this is within the range of people's intense emotions.

> I watched you write calligraphy today and then looked at some of your photographs. I wonder if Chinese painting has influenced you.

I should say that the influence is quite big. Chinese landscape painting after the Song dynasty [960–1279] has greatly influenced me. Mainly it is the contours of the paintings. Among the modern paintings, the splash-ink technique of Chinese ink paintings has made a deep impression on me. The Ming dynasty [1368–1644] painter Bada Shanren [1626–1705] also has had a significant influence on me. His paintings are very simple. . . . You can say his paintings are abstract to the extreme. There is also the most famous Tang dynasty [618–907] painter, Wu Daozi [active c. 710–760]. Once, at the White Cloud Temple, in a Daoist temple, I saw a dragon that he had painted using the splash-ink technique. These are all considered to be abstract.

Chinese painting has a few important characteristics. One is simplicity, the use of just rice paper and ink. The biggest enlightenment I got from Bada Shanren's painting style is from all of the white space he left in his paintings; so I do the opposite and leave black in my photographs. He left white space in his paintings because he was painting on white paper; I leave black space on my pictures because I'm painting on a black slide, a black negative. All of the physics and chemistry of

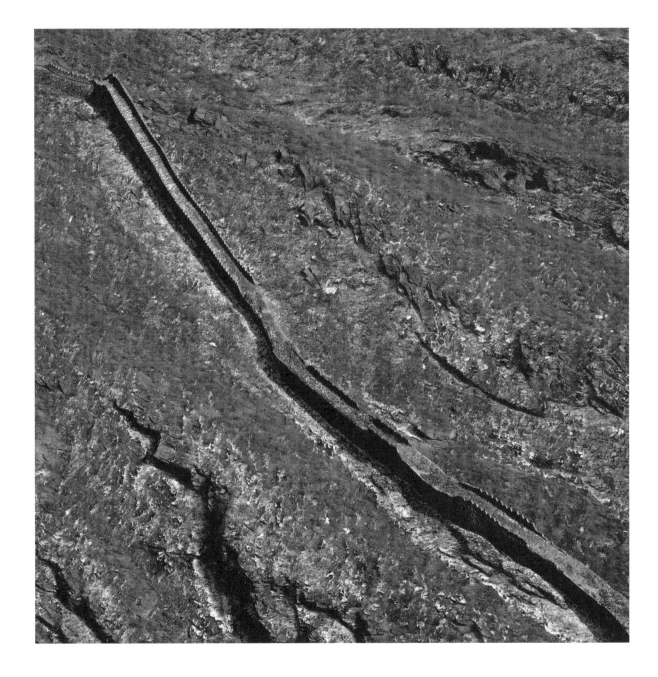

photography are undertaken in the dark, so black is the essence of photography. Also, I want to leave black for the reader and the audience, without telling them every detail of the photograph. I hope to make the author and reader think beyond the photograph's surface. This is an important element of Chinese culture. Harmony, simplicity, abstraction—these are the most basic elements of painting and art around the world.

However, I don't directly imitate Chinese paintings in my photographs. Instead, I just find the feeling in them. There are many photographic works that imitate Western oil paintings and watercolors. I'm very opposed to directly imitating painting in photography. If you want to get the good features of paintings, it must be indirect—the finding of a feeling, and that's enough. The key is that, from a grounding in basic skills, you can see the traces of painting techniques and see its shadows, but you are certainly not allowed to see its actual appearance.

Please talk about your use of Epson printers to print photographs on rice paper.

Epson printing provides more freedom than traditional photography. The work is done in a lit room as opposed to a darkroom, using modern-day computer techniques.

The surface of the works on rice paper is also completely different?

That's why I don't like to use Epson's coated paper. The coated surface prevents color from seeping into the Epson paper, so I've been experimenting with Chinese rice paper. When I printed with Epson, I found that its color can be absorbed by the rice paper. I think it can create a kind of texture. With an absolutely flat surface, the feeling of texture is lacking.

You retired in 1985 or 1986?

No, strictly speaking it was 1998; but starting in 1990, I began to have a kind of creative freedom. This was mainly because I resigned from my positions, including the position of deputy chief editor of the magazine. At that time, the leadership wanted me to be chief editor, but I believed it was more interesting to be a photographer than it was to be a chief editor.

So this cleared some time for your photography projects?

On one hand, this gave me full control of my time; on the other, I would have to absorb all of my photography expenses. During this change my family members, especially my wife, were all very supportive. You could say that they supported my photography work with all of their strength.

Climbing the Great Wall can be a very arduous exercise. Do you enjoy climbing the Wall?

Climbing the Wall is a kind of exercise for someone my age. Actually I have fully blended with the Great Wall, which has become an important organizing part of my life. You could say that I've given my whole life to the Great Wall.

How difficult is the process of getting to some of the places in your pictures?

Now it is often relatively easy, but in the beginning it was very arduous. Often there were no roads. The Great Wall I've discovered might be different from that reported by the media. It pleases me that sections of the Wall that I've been to and photographed have gradually disappeared, just like the sections you've seen during your trip to the northwest that might disappear soon. You can say: "I have seen the Great Wall, but you can't see it now."

Is this a pleasure?

Yes. I felt saddened when I saw the Great Wall being destroyed and slowly disappearing. But in another sense, after it disappeared, it returned to nature, and my mind felt placid, because, after all, the Great Wall is a wall, and it is a wall that divides. If the Wall no longer exists, then people can get along with each other without obstruction. So while shooting the Wall, I often go through states of complex emotional change, because as soon as I tell everyone about the Wall's best natural scenery, this place will suffer. This is my greatest conflict. I have no power to protect the original state of that place. The government has also spent a great deal of money to restore the Wall, but some restored parts of the Wall no longer have their original splendor, and in restoring the Wall, some modern materials like cement and reinforcing steel were used, so it makes it very difficult to express the original state of the Wall.

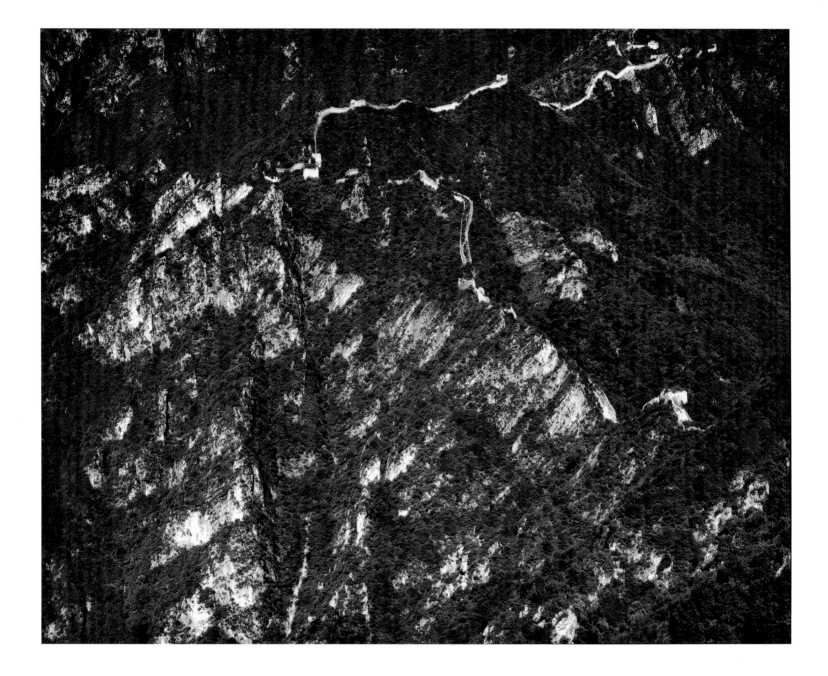

We have seen some parts of the Wall that have been restored well, like the Qingshanguan Fortress of the Ming dynasty, while some parts of the Wall are not well restored, where they added some things that shouldn't have been added.

At the Qingshanguan Fortress you said something really great, which I tell people when I go to different parts of China. You said that there is something very sacred about this part of the Wall.

I felt this sacredness during the whole trip across China, and at one point, at Yumenguan, I saw a man climb over the fence and walk on this fragile, two-thousand-year-old wall. It took everything in me not to scream at him. I wanted to tell him that this wall is older than your grandfather and your great-grandfather. Have some respect! But he was trying to get a better camera view. So, for the sake of a photograph that would go in an album and then be forgotten, he ruined another piece of the Wall.

The first time I went to Yangguan, Chen Peng and I climbed to the top. The second time we were not allowed to climb to the top; and the third time we could not get inside.

It is like the Mogao Caves. The carbon dioxide from the tourists' breath is damaging the caves. Apparently attendance is doubling every year at the caves and at Jiayuguan. On one level, there is more money to protect it, but it needs more money because of increased attendance.

It forms a vicious cycle.

In the past, you did not note specific locations when you published your work. Was this to protect the place and avoid starting this cycle?

Sometimes I did mention the specific locations, but I want to show the overall image of the Great Wall to our descendants. This is the Wall that I have seen in the years of my life. Maybe after fifty years, one hundred years, the Wall seen by our descendants will be different from what it is now. Maybe there

will be some people who take my books and go to those same places to photograph, and they will discover the changes the Wall has experienced over many years. But no matter how the Great Wall changes, each person, each artist, will find his or her own vision.

Are there any sections of the Wall that you have not photographed, but still want to address?

The northernmost part of Beijing Province, about three hundred kilometers away. It is a short distance, but the roads are rough. The quality of the roads varies, and I have not been to some places in a long time because of road conditions.

What reaction do you hope people will have when they come to this exhibition of your photographs of the Great Wall?

The reaction that I most want is that the Great Wall that I have photographed is different from the Great Wall they have seen.

You don't mean physically different, but different because you have photographed in places that they cannot go?

Right. My perceptions are different. I hope they can learn from the pictures about the Wall and enjoy the crystallization of labor and of the wisdom of mankind.

The photographs are centered on many things, including the greatness of the Wall's construction and the greatness of the effort of the Wall's laborers.

Yes. This does not apply to only one nation or one country. There are many structures like this in the world.

You are photographing people who live along both sides of the Wall—part of the reason is that they represent the people who lived there and built the Wall centuries ago.

When I started photographing the people living on both sides of the Wall in 2001, I had originally wanted to complete the project by 2006 or 2007 because there is something happening along the Wall that I can't stand seeing: in order to increase tourism, in many areas people living along the wall have been moved to other places. I believe that if the Great Wall does not have natural villages and people it will be hard for it to be a complete Great Wall; it would become isolated. It won't be meaningful if tourists just look at the Wall. I would hope that visitors could see the Wall itself, as well as the people living on both sides of it—the simple way they live, as well as the contributions their ancestors once made to the Great Wall. There is no way for us to see the ancients who built the wall, but if we can see their descendants still living there in good health, we can feel happy. I believe this is history.

That is a good ending to our conversation.

Biography

1941	Born in Hunan Province, central southeast China
1959	Began to work as a photographer
1959–63	Attended the Aviation School of the Civil Aviation Administration of China [CAAC] in Beijing
1960	First visit to the Great Wall
1963	Began work with the CAAC, Beijing
1965	Began to photograph the Great Wall, a subject that he would continue to photograph for more than forty years
1966–76	The Cultural Revolution
1980–present	Member of the Association of Chinese Photographers, Beijing
1981	Helped establish the Beijing-based CAAC in-flight magazine; he later was named deputy editor-in-chief, a position he held until 1989
1987	Received the Best Professional Photographer Award from the Swiss publication *Graphic Photos 87* in recognition of his photograph *The Ten-Thousand Miles of Mountain Passes (Guan Shan Wan Li)*, which was reproduced on the cover of *Wings China* magazine that same year
February 1988	First symposium on Chen Changfen's photography, held by the Association of Chinese Photographers, Beijing
October 1989	Awarded the Gold Statue in China's First Photographic Arts Prize by China Photographers Association
1991	Member of the editorial committee of *Chinese Photography* magazine, also in 1992, 1993, 1995, 1997, and 2003–6
1992	Awarded a grant by the Chinese government for his contribution in news media and publications; the award is a stipend given by the State Council of the People's Republic of China
1992	Traveled to Europe to study public sculpture on a group trip organized by the Chinese Cultural Department
1997	Director of the Association of Chinese Photographers, Beijing
1999	President of China Civil Aviation Photography Association, Beijing
1999	Created the Web site www.chenchangfen.com
June 1999	Acted as special envoy of Kodak Professional Photography in China
2000	Vice president of China Arts Photography Association, Beijing
November 2000	Established Chen Changfen Art Gallery, Beijing

	2001	Committee member of the China Federation of Literary and Art Circles, Beijing
	2001–present	Committee member of the seventh China Federation of Literary and Art Circles
	November 2003	Chief art reviewer for *Civil Aviation in China Today*, a book celebrating the hundred-year anniversary of man-powered flight
	2005	Named "Master of the Century" by Longines, Switzerland
Exhibition History Solo	**June 1987**	Chen Changfen Art Photography, China Art Gallery, Beijing
	August 1999	The Great Wall: Epic Poem, China Art Gallery, Beijing [58 works]
	April 2003	By invitation, an exhibition of his photographs is held at the American Embassy in Beijing
	October 2003	The Most Challenging Expressway in China, Guangzhou Art Museum, Guangzhou
Group	**1996**	The Hada Brought Back from Tibet, Bei Douxing Gallery, Beijing
	April 2000	Save Nature, Xiang Sheng Gallery, Beijing [20 photographs]
	November 2000	Permanent exhibition, Hing Dian (Cinematography Center), Zhejiang Province
	August 2002	A selection of his work is exhibited in The Great Wall: One of the World's Earliest Networks, Denver [a conference]
	October 2004	By invitation, his work is included in the Forbidden City International Photograph Exhibition, the Palace Museum, Forbidden City
	September 2005	By invitation, his work is exhibited at the Pingyao International Photography Exhibition, Pingyao, September 16–22, 2005
	November 2005	By invitation of the Olympic Committee, his work is exhibited in Charming Beijing in Washington at the Kennedy Art Center, Washington, D.C.
Publications Books	**September 1987**	En Yang, *The Works of Chinese Photographer Chen Changfen* (Zhongguo she ying jia Chen Changfen zuo pin ji), 1st ed. (Beijing: Chinese People's Art, 1987).
	August 1988	Wu Shouming, ed., *The Great Wall of China* (Shi Jiazhuang City: Hebei Fine Arts, 1988). [Chen's work is reproduced in the book]
	April 1989	David Cohen, *A Day in the Life of China* (San Francisco: Collins, 1989), 46, 216; reproductions, 38, 48–49, 140–41, 172–73, 202–3.

September 1990	Chen Changfen and Hibino Takeo, *Chojo: bunmei no kairo* (The Great Wall: A cultural walkway) (Tokyo: Kawade Shobo Shinsha, 1990). [monograph, Japanese]	
1994	Chen Changfen, *The End of the Earth* (Hainan: China Hainan Photography and Fine Arts, 1994). [photography book]	
January 1997	Naomi Rosenblum, *A World History of Photography*, 3rd ed. (New York: Abbeville, 1997), 561–62, plate 726.	
1999	*China: Fifty Years Inside the People's Republic* (New York: Aperture, 1999). [half-title page]	
2003	Chen Changfen, *Sanya* (Sanya China) (Beijing: Hainan Province Government, 2003).	
October 2003	Chen Changfen, *The Most Challenging Expressway in China* (Beijing: Jiu Zhou, 2003). [photographs of the Beijing-Zhuhai Expressway]	
2005	Pan Min, *Lieu de Mémoire: Changfen Chen (South Yunan Impressions: Photographs by Chen Changfen)* (China: Chinese Photographic, 2005).	

Articles

1987	"Photographs by Chen Changfen," *Chinese Photography* (China), no. 1, (1987): 24–25.	
1987	"A Wide Field of Vision: The Art of Chen Changfen," *Chinese Photography* (China) no. 1 (1987): 37–39.	
1988	Photos by Chen Changfen, *Chinese Photography* (China), no. 3 (1988): 24, 25, 36.	
August 1989	Richard Heinemann, *Time*, August 1989 (Asian edition, published to celebrate 150 years of photography). *Time* magazine featured Chen on the cover of an issue celebrating "industry pioneers whose contributions helped shape—and reshape—modern photography." The others whose images were reproduced with Chen's on the cover of the magazine included Louis Daguerre, William Henry Fox Talbot, George Eastman, Edwin Land, Joseph Nicephore Niepce, Leif Preus, Minoru Ohnishi, Bruno Uhi, and Marella Agnelli.	
1990	Wu Xiaochang, "Some Inspirations from the Work *Sky* by Chen Changfen," *Chinese Photography* (China), no. 2 (1990): 11. [cover]	
1993	Wu Changyun, "New Works by Chen Changfen," *Chinese Photography* (China) (December 1993): 12, 19–27.	
February 1997	"Chen Changfen," *HQ* (Germany), no. 38 (February 1997): 4–25. [51 illustrations]	
1997	Text by Aqua Portfolio, *Forum 1*, vol. 33 (1997): 18. [reproduction of *Yun Nan, China*]	
1998	"Beijing, China. Shanxi, China. Nine Villages, China." *Forum 2*, vol. 34 (1998): 42–45. [a selection of works reproduced]	

1998 Xiang Pu, "Photographs Capture Time and Space," *China Daily*, February 25, 1998, 5.

April 1999 Jason Schneider, "The Great Wall Project," *Popular Photography* (April 1999): 78–79, 98.

1999 Haijun Dou, "An Impassible Enemy Tower," *CAAC* (Civil Aviation Administration of China in-flight magazine) (1999): 68–70, 72, 74, 76.

August 1999 Wu Changyun, "The Great Wall Epic: Photos by Chen Changfen," *Chinese Photography* (China) (August 1999): 2–11. [interview]

2000 Chen Changfen, "The Professional Classroom," *Chinese Photography* (January 2000–December 2000). [monthly column, 12 issues]

June 2000 Jia Liming, "Chen Changfen Does Not Talk About Pursuit," *Traveler* (Beijing) 54 (June 2000): 98–100.

2001 Li Wang, "Flying on Land," *Chinese National Geography* (China) (September 2001): 9–18.

2003 Chen Changfen, "Look Up: The Great Wall," *Chinese National Geography* (China) (August 2003): 24–29. [text and photographs by Chen Changfen]

July 2004 Wu Changyun, "Color or B&W: An Interview with Chen Changfen," *Chinese Photography* (China) (July 2004): 44–55.

Chen also has published articles in *Rolls-Royce Magazine* of Britain, *Hasselblad Forum* of Sweden, and other magazines, as well as supplied news photo stories for China Central Television, China Central Radio Station, Hong Kong Phoenix Television, and local television stations. He also has judged national and international competitions. He has lectured widely at numerous universities, including the MBA Institute of Beijing University, Tsinghua University, several film institutes, and at China Central Arts and Crafts Institute. He has traveled professionally in the United States, Sweden, the former Soviet Union, Thailand, Turkey, Germany, Romania, Belgium, France, Greece, Hungary, Poland, Japan, former Czechoslovakia, Hong Kong, and Macao.

All black-and-white photographs are printed on 20 x 24–inch gelatin silver paper, and all color photographs, except the panoramas, are inkjet photographs on 29 1/8 x 39 3/8–inch rice paper. The panoramic photographs are inkjet photographs printed on silk and mounted as a scroll. The photographer's numbers refer to the photographer's own inventory system.

Color photographs

1

ANBIAN, SHANXI PROVINCE, 1998

Plate 00; photographer's #: ccf. tgw. 66C 01–012

2

YULIN, SHAANXI PROVINCE, 2005

Plate 00; photographer's #: ccf. tgw. 66C 01–014

3

BAOTOU, NEIMENGGU PROVINCE, 1997

Plate 00; photographer's #: ccf. tgw. 66C 01–023

4

JIAYUGUAN, GANSU PROVINCE, 1986

Plate 00; photographer's #: ccf. tgw. 66C 01–032

5

SHUIGUAN, BEIJING, 1997

Plate 00; photographer's #: ccf. tgw. 66C 02–034

6

JUYONGGUAN, BEIJING, 1986

Plate 00; photographer's #: ccf. tgw. 66C 02–036

7

XISHUIYU, BEIJING, 1996

Plate 00; photographer's #: ccf. tgw. 66C 03–002

8

HUANGHUACHENG, BEIJING, 1995

Plate 00; photographer's #: ccf. tgw. 66C 03–006

9

HUAIROU ZHUANGHU, BEIJING, 1996

Plate 00; photographer's #: ccf. tgw. 66C 03–029

10

WANGQUANYU, BEIJING, 1995

Plate 00; photographer's #: ccf. tgw. 66C 03–036

11

ZHUANGHU, BEIJING, 1996

Plate 00; photographer's #: ccf. tgw. 66C 03–043

12

JIUYANLOU, BEIJING, 1996

Plate 00; photographer's #: ccf. tgw. 66C 04–003

13

BEIJINGJIE, JIANKOU, BEIJING, 1999

Plate 00; photographer's #: ccf. tgw. 810C 04–018

14

BEIJINGJIE, JIANKOU, BEIJING, 1997

Plate 00; photographer's #: ccf. tgw. 66C 04–023

15

BEIJINGJIE, JIANKOU, BEIJING, 1997

Plate 00; photographer's #: ccf. tgw. 66C 04–024

16

YINGFEIDAOYANG, JIANKOU, BEIJING, 1990

Plate 00; photographer's #: ccf. tgw. 66C 04–027

17

XIDAQIANG, JIANKOU, BEIJING, 1992

Plate 00; photographer's #: ccf. tgw. 66C 04–040

18

YOULOULING, JIANKOU, BEIJING, 1994

Plate 00; photographer's #: ccf. tgw. 66C 05–010

19

SUOBOLOU, JIANKOU, BEIJING, 1995

Plate 00; photographer's #: ccf. tgw. 66C 05–012

20

SUOBOLOU, JIANKOU, BEIJING, 1995

Plate 00; photographer's #: ccf. tgw. 66C 05–014

21

JIANKOU, BEIJING, 1995

Plate 00; photographer's #: ccf. tgw. 66C 05–015

22

XIZHAZICUN, BEIJING, 1996

Plate 00; photographer's #: ccf. tgw. 66C 05–016

23

JIANKOU, BEIJING, 1997

Plate 00; photographer's #: ccf. tgw. 66C 05–018

24

NIUJIJIAOBIAN, BEIJING, 1989

Plate 00; photographer's #: ccf. tgw. 66C 05–037

25

SIMATAI, BEIJING, 1994

Plate 00; photographer's #: ccf. tgw 66C 08–001

26

LAOLONGTOU, SHANHAIGUAN,
HEBEI PROVINCE, 2000

Plate 00; photographer's #: ccf. tgw. 66C 09–006

27

SHANHAIGUAN, HEBEI PROVINCE, 2005

Plate 00; photographer's #: ccf. tgw. 810C 09–008

Black-and-white photographs

28

BAOTOU, NEIMENGGU PROVINCE, 1999

Plate 00; photographer's #: ccf. tgw. 810B 01–008

29

DUNHUANG, YUMENGUAN,
GANSU PROVINCE, 1998

Plate 00; photographer's #: ccf. tgw. 810B 01–015

30

DUNHUANG, YUMENGUAN, GANSU PROVINCE, 1998

Plate 00; photographer's #: ccf. tgw. 810B 01–017

31

HEQUPIANGUAN, SHANXI PROVINCE, 1999

Plate 00; photographer's #: ccf. tgw. 810B 01–055

32

QINGLONGQIAO, BEIJING, 2002

Plate 00; photographer's #: ccf. tgw. 810B 02–031

33

DAZHENYU, BEIJING, 1998

Plate 00; photographer's #: ccf. tgw. 810B 03–013

34

XIDALOU, BEIJING, 1998

Plate 00; photographer's #: ccf. tgw. 810B 03–017

35

DAZHENYU, BEIJING, 1997

Plate 00; photographer's #: ccf. tgw. 810B 03–018

36

WANGQUANYU, BEIJING, 1998

Plate 00; photographer's #: ccf. tgw. 810B 03–028

37

JIANKOU, BEIJING, 1998

Plate 00; photographer's #: ccf. tgw. 810B 04–011

38

YINGFEIDAOYANG, HEIHUDONG, JIANKOU, BEIJING, 2002

Plate 00; photographer's #: ccf. tgw. 810B 04–012

39

YINGFEIDAOYANG, JIANKOU, BEIJING, 2001

Plate 00; photographer's #: ccf. tgw. 810B 04–024

40

XIDAQIANG, JIANKOU, BEIJING, 2001

Plate 00; photographer's #: ccf. tgw. 810B 04–026

41

BEIJINGJIE, JIANKOU, BEIJING, 2003

Plate 00; photographer's #: ccf. tgw. 810B 04–029

42

BEIJINGJIE, JIANKOU, BEIJING, 2002

Plate 00; photographer's #: ccf. tgw. 810B 04–031

43

BEIJINGJIE, JIANKOU, BEIJING, 1997

Plate 00; photographer's #: ccf. tgw. 810B 04–034

44

YINGFEIDAOYANG, JIANKOU, BEIJING, 2002

Plate 00; photographer's #: ccf. tgw. 810B 04–041

45

YINGFEIDAOYANG, TIANTI, JIANKOU, BEIJING, 1998

Plate 00; photographer's #: ccf. tgw. 810B 04–042

46

YINGFEIDAOYANG, JIANKOU, BEIJING, 1998

Plate 00; photographer's #: ccf. tgw. 810B 04–043

47

JIANGJUNSHOUGUAN, JIANKOU, BEIJING, 2002

Plate 00; photographer's #: ccf. tgw. 810B 04–052

48

JIANGJUNSHOUGUAN, JIANKOU, BEIJING, 2002

Plate 00; photographer's #: ccf. tgw. 810B 04–053

49

JIANKOU, BEIJING, 2001

Plate 00; photographer's #: ccf. tgw. 810B 04–081

50

YOULOULING, JIANKOU, BEIJING, 2004

Plate 00; photographer's #: ccf. tgw. 810B 05–018

51

YOULOULING, JIANKOU, BEIJING, 2004

Plate 00; photographer's #: ccf. tgw. 810B 05–019

52

JIANKOU, BEIJING, 1999

Plate 00; photographer's #: ccf. tgw. 810B 05–031

53

JIANKOU, BEIJING, 1997

Plate 00; photographer's #: ccf. tgw. 810B 05–045

54

SUOBOLOU, JIANKOU, BEIJING, 1998

Plate 00; photographer's #: ccf. tgw. 810B 05–083

55

SUOBOLOU, JIANKOU, BEIJING, 2000

Plate 00; photographer's #: ccf. tgw. 810B 05–098

56

JIANKOU, BEIJING, 2000

Plate 00; photographer's #: ccf. tgw. 810B 005–099

57

JIANKOU, BEIJING, 1998

Plate 00; photographer's #: ccf. tgw. 66B 05–119

58

JIANKOU, BEIJING, 2001

Plate 00; photographer's #: ccf. tgw. 810B 05–133

59

GUBEIKOU, BEIJING, 2000

Plate 00; photographer's #: ccf. tgw. 810B 07–007

60

JINSHANLING, HEBEI PROVINCE, 2000

Plate 00; photographer's #: ccf. tgw. 810B 07–028

61

JINSHANLING, HEBEI PROVINCE, 1993

Plate 00; photographer's #: ccf. tgw. 66B 07–088

62

JINSHANLING, HEBEI PROVINCE, 1998

Plate 00; photographer's #: ccf. tgw. 66B-07–089

63

SIMATAI, BEIJING, 1998

Plate 00; photographer's #: ccf. tgw. 810B 08–021

Panoramas

64

BEICHAKOU, NINGXIA PROVINCE, 2002

12 x 68 inches (30.5 x 172.1 cm)

Plate 00; photographer's #: ccf. tgw. W 010–009

65

YINCHUAN, NINGXIA PROVINCE, 2002

12 x 86 inches (30.5 x 220 cm)

Plate 00; photographer's #: ccf. tgw. W 01–010

66

DATONG, SHANXI PROVINCE, 2001

12 x 116 inches (30.5 x 293.6 cm)

Plate 00; photographer's #: ccf. tgw. W 01–019

67

JIANKOU, BEIJING, 2002

12 x 109 inches (30.5 x 279.4 cm)

Plate 00; photographer's #: ccf. tgw. 04–035

68

JIANKOU, BEIJING, 2002

12 x 165 inches (30.5 x 419.9 cm)

Plate 00; photographer's #: ccf. tgw. W 04–028

69

JINSHALING, HEBEI PROVINCE, 1998

12 x 86 inches (30.5 x 218.4 cm)

Plate 00; photographer's #: ccf. tgw. W 08–011

70

JINSHANLING, HEBEI PROVINCE, 2000

12 x 96 inches (30.5 x 243.3 cm)

Plate 00; photographer's #: ccf. tgw. W 08–016

71

QIANXI, HEBEI PROVINCE, 1998

12 x 73 inches (30.5 x 185.4 cm)

Plate 00; photographer's #: ccf. tgw. W 09–003

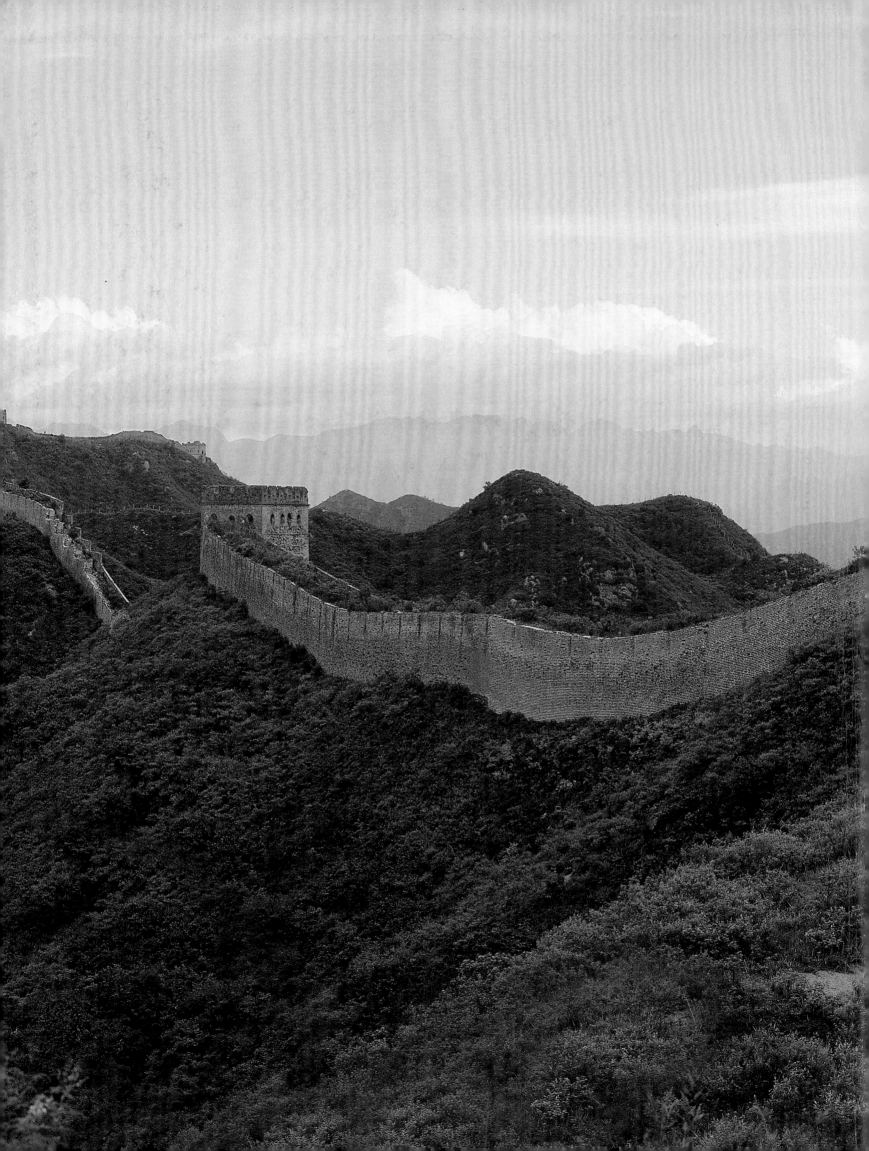